MARYLYN DINTENFASS
DROP DEAD GORGEOUS

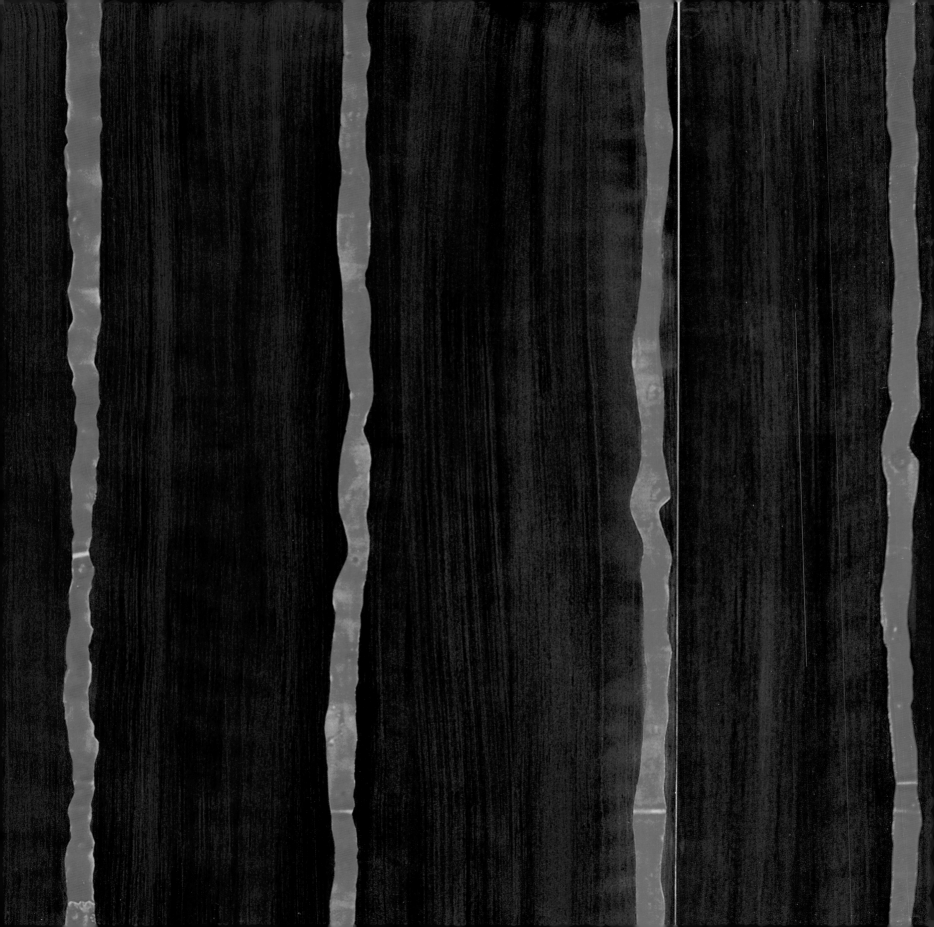

MARYLYN DINTENFASS
DROP DEAD GORGEOUS

SCOTT INDRISEK

INTRODUCTION BY
JOHN DRISCOLL

DRISCOLL | BABCOCK

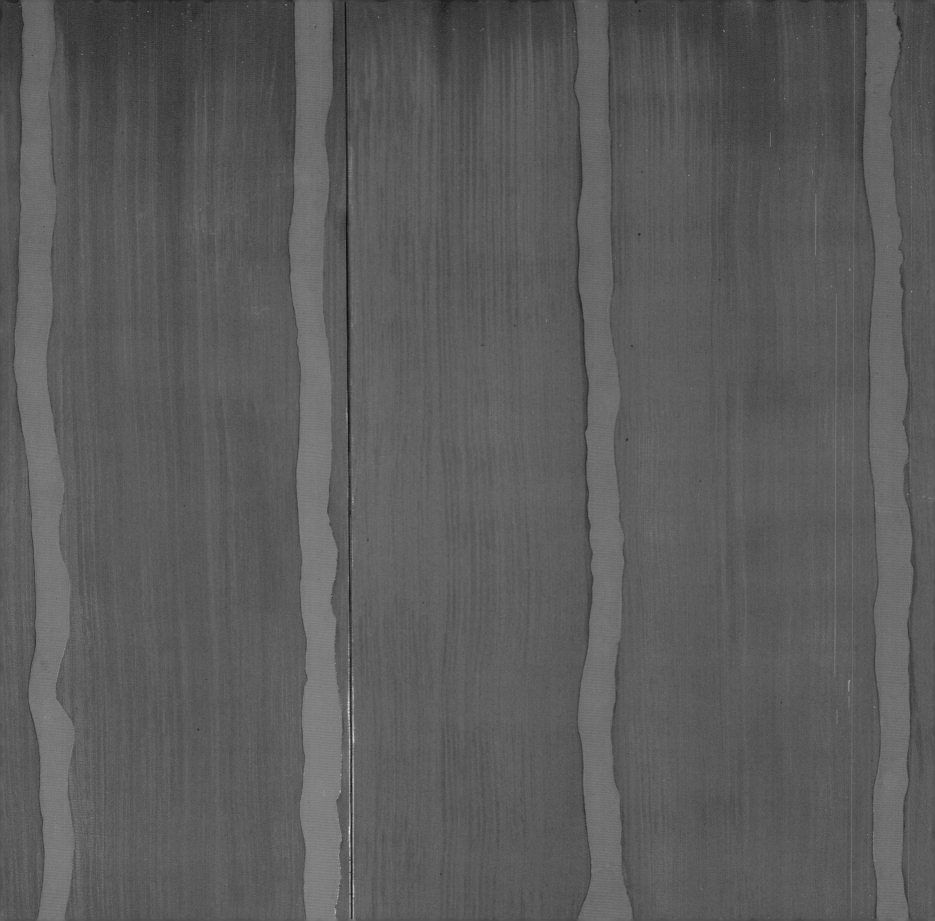

Drop dead gorgeous is Marylyn Dintenfass' latest series of images derived from her interest in psychologically and intellectually contradictory dualities, in this case, beauty that is toxic. Dintenfass' work has always been based on line delineating the shapes in her work, on shapes defining space and form— all of which are articulated by color.

Line is in the DNA of her work, it is one of the essentials in creating the body impact of her images, the visceral feel of standing in front of—or even next to—one of her images. When on a large scale, as in many of the paintings illustrated on the pages that follow, there is of course the visual impact of an image. But more important to Dintenfass is that visceral wonder, that shock to the body, freight train through the chest that one can experience upon encountering her linear, chromatic, layered, organic and structural naturalistic abstractions. She exalts in getting beyond visual impact, she strives for perceptual impact, of an enlivened full body and senses experience.

The exhibition, and this publication, follows the process by which the major paintings were created, incorporating the investigative moments in which ideas and details conjured by the larger paintings are addressed in smaller works. This is not a matter of chronology, it is a matter of process. The sequence is a process sequence. In some ways, these paintings are the most literal of her career, so far. Her work has always struck people as abstract, as organic abstraction, as experiential painting. For Dintenfass, the images have always been literal transcriptions of experiences, of something felt or known, of places visited, of things encountered: representations of the domain in which she thinks. Her realism is another's abstraction.

In the DROP DEAD GORGEOUS series however, one gets a distinct inkling of the stems of plants, of sharp thorns, of luscious and bulbous blossoms: of something recognizable that is offset by powerful, acidic and almost radioactive color. The shapes and forms in the images are beautiful...or are they? Dintenfass is one of the great colorists of our time and her use of color is certainly beautiful...or is it?

The plants that attracted her attention, and that are at the root of her imagery in this series, are all gorgeous to look at: elegant, curvaceous, splendid in their forms, shapes and lines...beautiful beyond words, but also profoundly toxic. These are plants that will kill you. Things are, and are not, what they seem. Ignorance is not bliss. Yet in the studio, in the paintings, Dintenfass conceives her images, creates visual manifestations of her experiential reality and in the sure knowledge of her creative self and of her artistic vision, expresses her bliss—expresses what is truly drop dead gorgeous.

JOHN DRISCOLL

OPPOSITE SEEDS OF ABDUCTION (DETAIL) 18/19
FRONTISPIECE BREATH IN THE AFTERBLOOM (DETAIL) PAGE 20/21

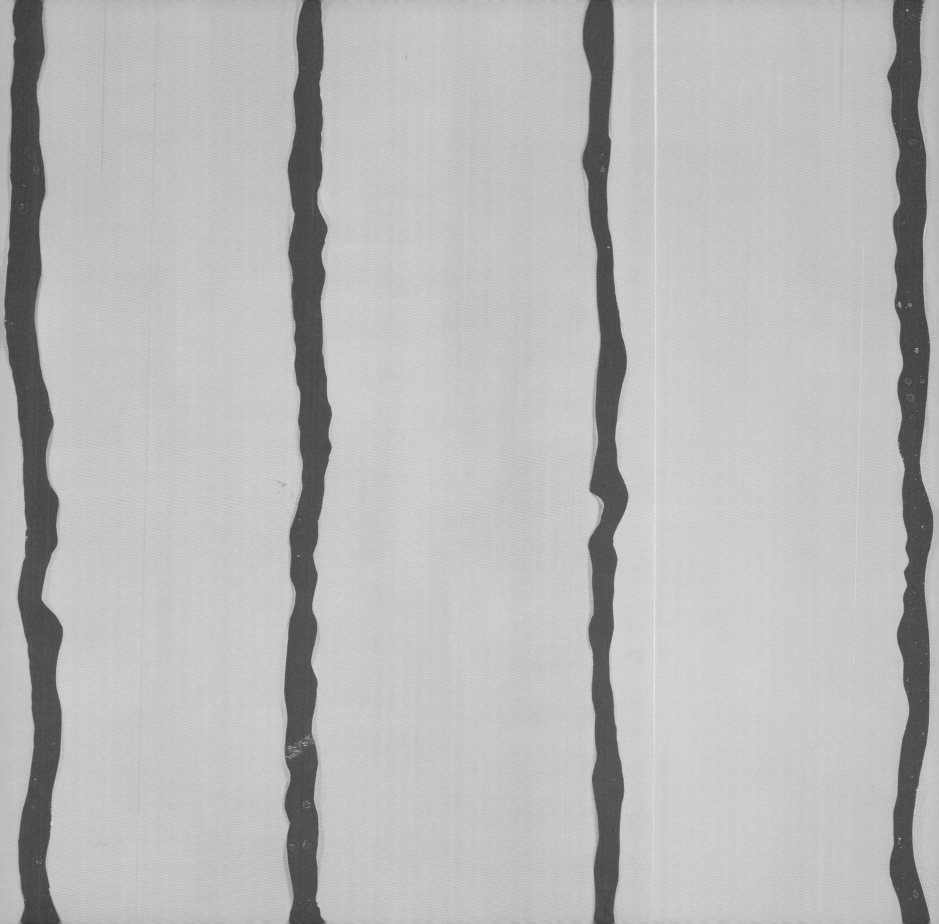

IN BLOOM
MARYLYN DINTENFASS AND DROP DEAD GORGEOUS

SCOTT INDRISEK

Enter the world of DROP DEAD GORGEOUS and it is quickly clear that things are not what they seem. The massive canvases in the series depict the lush, luridly colored bloom of an unfamiliar flower. Don't get too comfortable with its pretty façade—it's the Angel's Trumpet, a botanical specimen with a deceptively sweet name and a venomous disposition. Marylyn Dintenfass is obsessed with the flower's form, hanging upside down from its branch, a bit like an inverted palm tree. Yet her versions of the plant reimagine it in a wholly different color palette, a slice of acid trip Miami, which is perhaps fitting—the Angel's Trumpet is also a hallucinogenic drug that, if it doesn't kill you, will send you down some serious mind spirals.

Flowers, as a subject for contemporary art, have recently enjoyed something of a renaissance: witness the disparate work of Donald Baechler, Will Ryman, John McAllister, John Seal, Andrew Kuo, Holly Coulis and Ann Craven, to name only a few. However, it's rare that flowers in the 21st century are depicted as straightforward ornamentation, or in a conventional still life arrangement; rather, they're marshaled toward a larger conceptual purpose. In Dintenfass' most recent paintings, their tension lies with the juxtaposition of aesthetic appeal and lethality. "Some plants just make you sick," Dintenfass says, "but I wasn't interested in that." The artist began the work in the series by researching flora that could do serious and irrevocable damage to the human body: heart-stoppers,

pulse-enders. She found roughly a dozen potential options, all with darkly suggestive names, and some of which still might become the subject of later paintings: Devil's Helmet, Foxglove, Blood Flower. The Angel's Trumpet became the main focus of the series thus far, with a handful of additional canvases depicting the Bleeding Heart (pg. 26), among others.

OPPOSITE **SWEETLY SUBSUMED** (DETAIL) PAGE 24/25
ABOVE LEFT **DINTENFASS STUDIO**

The challenge became balancing the Trumpet's attractive veneer with its deadly nature. Early efforts, Dintenfass says, were simply too pretty; they failed to convey the underlying menace of the flower. "It was quite benign when I started. I kept pushing it to get that line where the beauty was there, but the danger was revealing its fangs, like a vampire." That meant cutting, refining and tweaking the Mylar templates used to replicate the Trumpet's form, suspended from a long, sinewy vertical stalk. "I used the scissors to create the shapes—'painting with scissors' similar to Matisse's gouaches découpés process—cutting and moving in," Dintenfass says. In some instances this results in a spiky, almost electrified form, as with TOKEN THORN PRICK (Fig. 1). Elsewhere, the curves of the flower's bulb are softened, while the internal coloring practically bursts its boundaries: the five specimens in the massive triptych KISSED BY NIGHTSHADE (pg. 22) pulse like aggravated heat maps. In SWEETLY SUBSUMED (Fig. 2) seven Angel's Trumpets stand out in stark, blood-red relief against a retina-shaking yellow. Dintenfass admits that her original names for these paintings were considerably darker, and included the litany of physical symptoms that result from ingesting the Angel's Trumpet. The titles she instead selected are derived from "poetry, Shakespeare and bawdy limericks," among other sources.

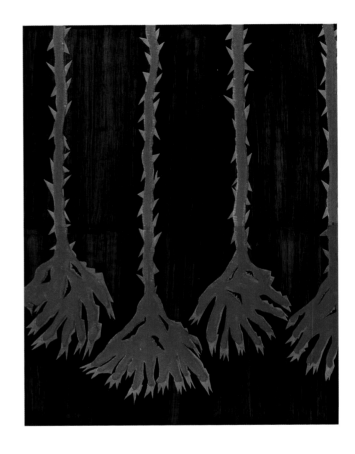

FIG. 1
TOKEN THORN PRICK 2012 PAGE 53

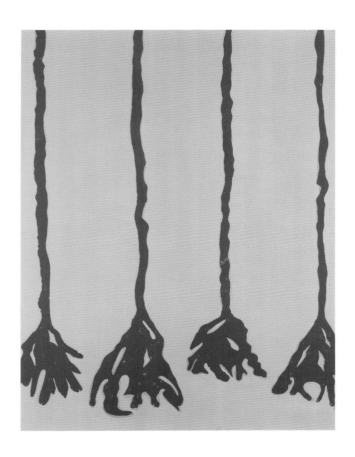

Above all, the paintings in DROP DEAD GORGEOUS unabashedly strive for beauty; they court the eye. It's a characteristic allure that Dintenfass has proudly foregrounded over several decades of work, since she moved beyond an early series of monochromatic sculptural objects. Her paintings are not coy about their desire to please, to provide what is—at the most superficial level—pure visual excitement. Yet there has always been a more complicated methodology beneath that surface. With the artist's previous series inspired by automobiles and candy, she often worked with a four-panel quadrant form that, she explains, generated an internal narrative logic: three similar, related panels and one outlier, a "truth-teller...an annotation of the rest of the painting." These latest large-scale works, conversely, present a single vision unified within mostly horizontal frames. The movement of the viewer's eye, rather than making a clockwise progression across four panels, is vertical, with the thin stem of each flower—like a scraggly Barnett Newman zip—cutting down the canvas, mirrored by the wash of color that Dintenfass applies in the background.

DROP DEAD GORGEOUS is also Dintenfass approaching her most representational. It's true that she's painted pieces inspired by flowers before—the four-paneled

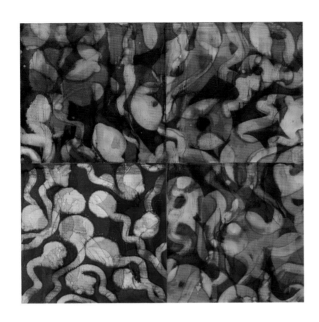

DAISY CHAIN (Fig. 4) from 2005, or a 2010 painting, CONSTITUTION MARSH (Fig. 3), conjured from a memory of the natural landscape of the wildlife sanctuary near the artist's upstate studio. In those cases, as with previous series informed by confections or classic cars, Dintenfass seriously abstracted her source material, transmogrifying it into pure color and form—like her signature ovaloids. Here, the deadly flowers that inspired the paintings are clearly recognizable, even if they have been broken down into their foundational parts and recast in a blazingly intense color palette. Dintenfass herself might take issue with such a characterization. "From my point of view, what I paint is not the transcription of something seen, but my experience of the thing encountered," she says. And of course, more is at stake here than a simple portrait of a deadly plant. Dintenfass accentuates the ribald undertones of both the Angel's Trumpet and the Bleeding Heart (Fig. 9): the former's "triangular" openings, the latter's phallic, anatomical innuendos. In this light, they're a more immediately punchy and impactful extension of Georgia O'Keeffe's vulvic flowers. Perhaps, for Dintenfass, sexuality itself is as deliciously nuanced and conflicted as these seemingly benevolent plants: beautiful on the outside, but laced with a potentially poisonous edge. At the very least, one should proceed with caution.

FIG. 3
CONSTITUTION MARSH 2010
OIL ON PANEL 48 X 48 INCHES

Followers of the artist's career thus far will also note two additional and vital changes in this body of work, pertaining to scale and surface. Dintenfass has long worked on panel, applying rich layers of color while working on the floor. For the first time, she has created works on large canvases, having sourced a high-quality, intensely archival French variety made with polyester. This allows for immersive diptychs and triptychs—103 x 154 inches, or 112 x 231 inches—which recontextualize the way one approaches the paintings. "When you stand next to a work like that, you're feeling it with your

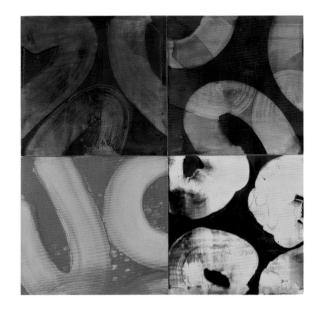

whole body," the artist says. While Dintenfass has certainly worked on an epic scale before—consider the 2009 public art project PARALLEL PARK in Fort Myers, Florida, which covered the surface of an entire parking structure (Fig. 6)—these are the largest paintings she has yet to show in a gallery context. That body-sensation is important, since the works beg one to come closer, which emphasizes the intricate details accomplished by working with the templates and layering paint to create a richly complex surface. "Scale is not something to take on thoughtlessly," Dintenfass says. "Things don't necessarily work big that work small." Standing in front of these large works—bringing your own body up close, until it is overshadowed by the canvas—one comes into intimate proximity with the grain of the paint,

FIG. 4
DAISY CHAIN 2005
OIL ON PANEL 48 X 48 INCHES

the effects of light and texture that Dintenfass achieves using translucent layers, varied brushes and drying agents whose unique alchemy conjures unpredictable patterns. The showstopping pieces here are complemented by a suite of more modestly-scaled oil-on-canvas and oil-on-panel works, and a number of exquisite collographs. These spotlight more discrete, specific parts of the floral body, and are akin to a photographic cropping technique, "going from the macro view and then moving in for a close-up." In VEIN OF MY EXISTENCE (Fig. 5) we see the jagged contours of the Angel's Trumpet in green, turquoise and red, placed against a lush blue background. WHEN THE SUN SHONE THE POISON FLOWER BREATHED COLD (Fig. 7) gives us a more ethereal, almost transparent Trumpet—fighting for

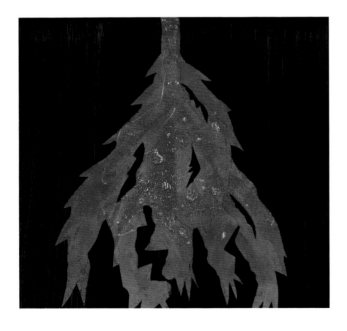

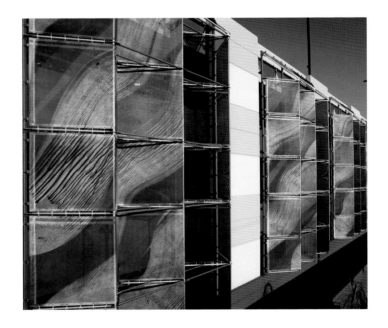

FIG. 5 (LEFT)
VEIN OF MY EXISTENCE 2012 PAGE 45

FIG. 6 (RIGHT)
PARALLEL PARK 2010
LEE COUNTY JUSTICE CENTER FORT MYERS FLORIDA
33 X 154 FEET (DETAIL) EAST FACADE

attention with the blaring solo yellow behind it. VENOM OF SUGGESTION (pg. 30) and CAME UPON A BURNING BUSH (Fig. 8) are a slight departure within the series' aesthetic, with interlocking all-over patterning and complex paint layering that recalls Dintenfass' four-paneled work. For these pieces, the artist has devised a hybrid flower that takes its cues from a number of carnivorous plants, including the *Drosera Regia* and *Sarracenia*. "They're extremely deadly," Dintenfass says, "but in a different and fascinating way. To me there is an anthropomorphic aspect to them, which I looked to capture in these two paintings. There is both a botanical and mammal impact to them, which comes from my reaction to the plants themselves."

 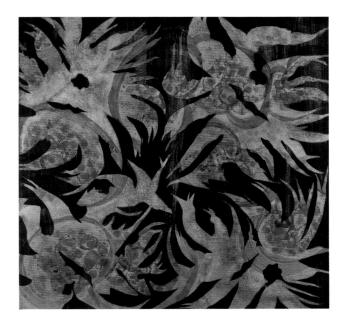

FIG. 7 (LEFT)
WHEN THE SUN SHONE THE POISON FLOWER BREATHED COLD 2012 PAGE 49

FIG. 8 (RIGHT)
CAME UPON A BURNING BUSH 2012 PAGE 33

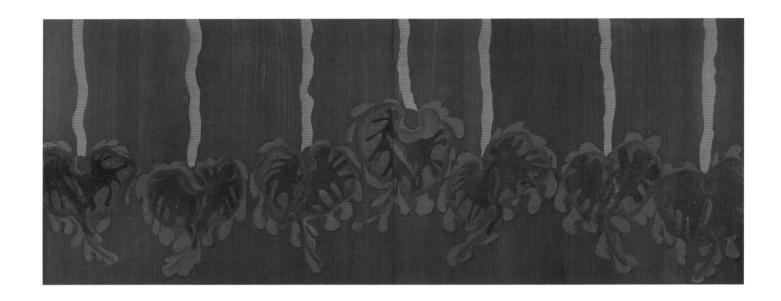

While Dintenfass is taking bold risks with new materials, scale and subject matter, one thing remains a constant in her practice: fidelity to a personal vision in which her inspirations are clarified and magnified through the medium of painting itself. "For me, painting is a totally intuitive process," Dintenfass says. "I express color the way a composer uses notes." The musical comparison is apt in this context, with a twist: in the Bible's "Book of Revelation", the sounding of seven angels' trumpets heralds a truly gruesome apocalypse, with seas turning to blood and a star named Wormwood crashing to earth. That might come as a surprise to the casual observer who, at first, sees in these paintings an unconflicted and purely ecstatic celebration of color and form. But as with everything else, these wickedly tempting paintings conjure—the simmering pull of sex and lust, the age-old attraction to the dangerously beautiful—there is more at play than meets the eye.

FIG.9 (ABOVE)
BLEEDING HEARTS MAKING A COMEBACK 2012 (DETAIL) PAGE 26/27
OVERLEAF **DINTENFASS STUDIO**

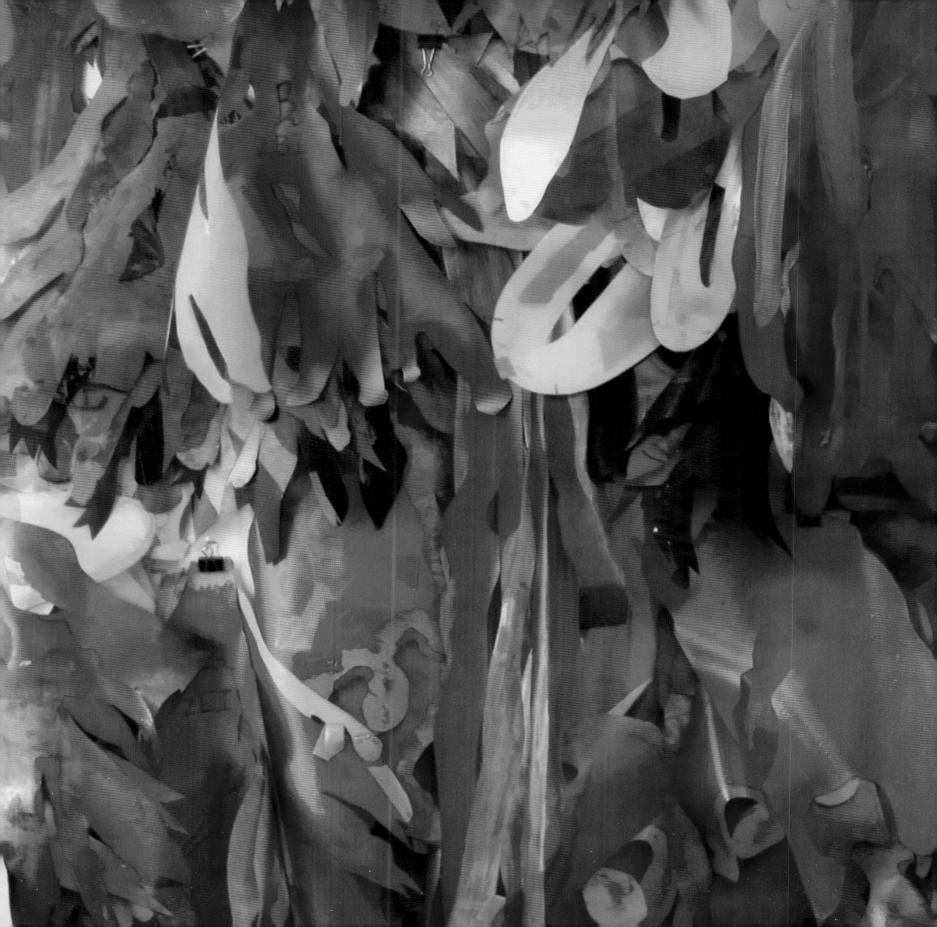

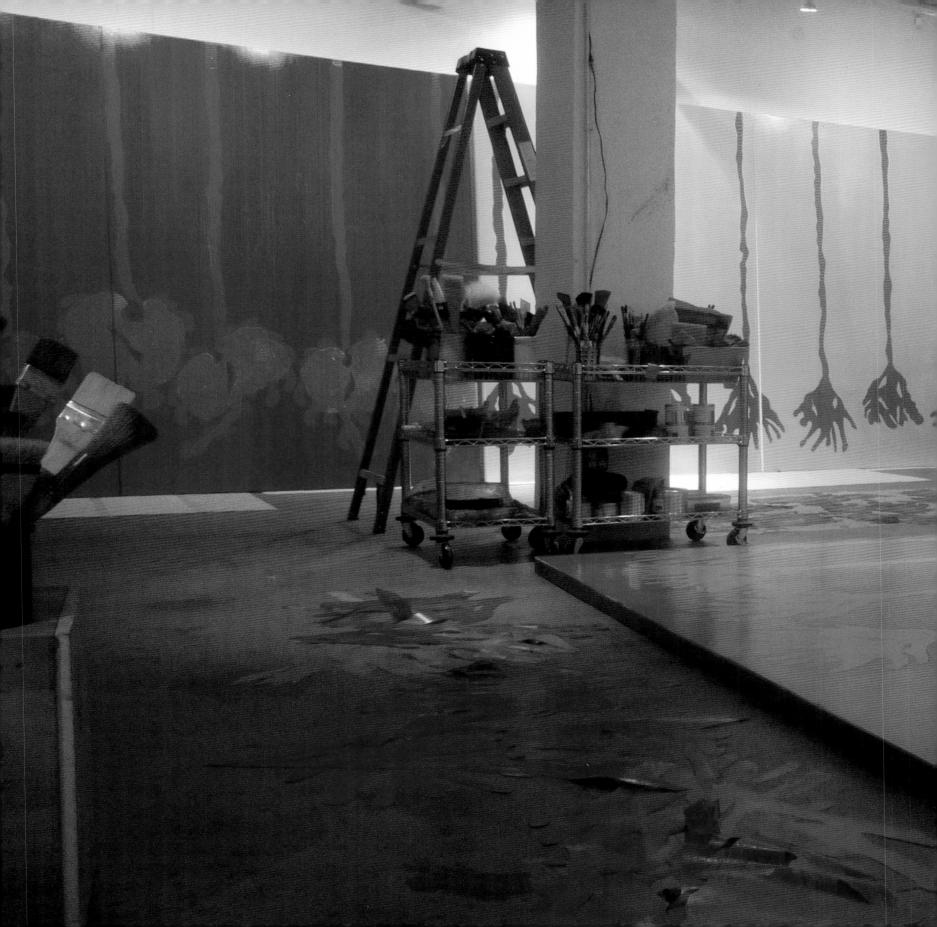

EXHIBITION PLATES

All dimensions in inches, height preceding width

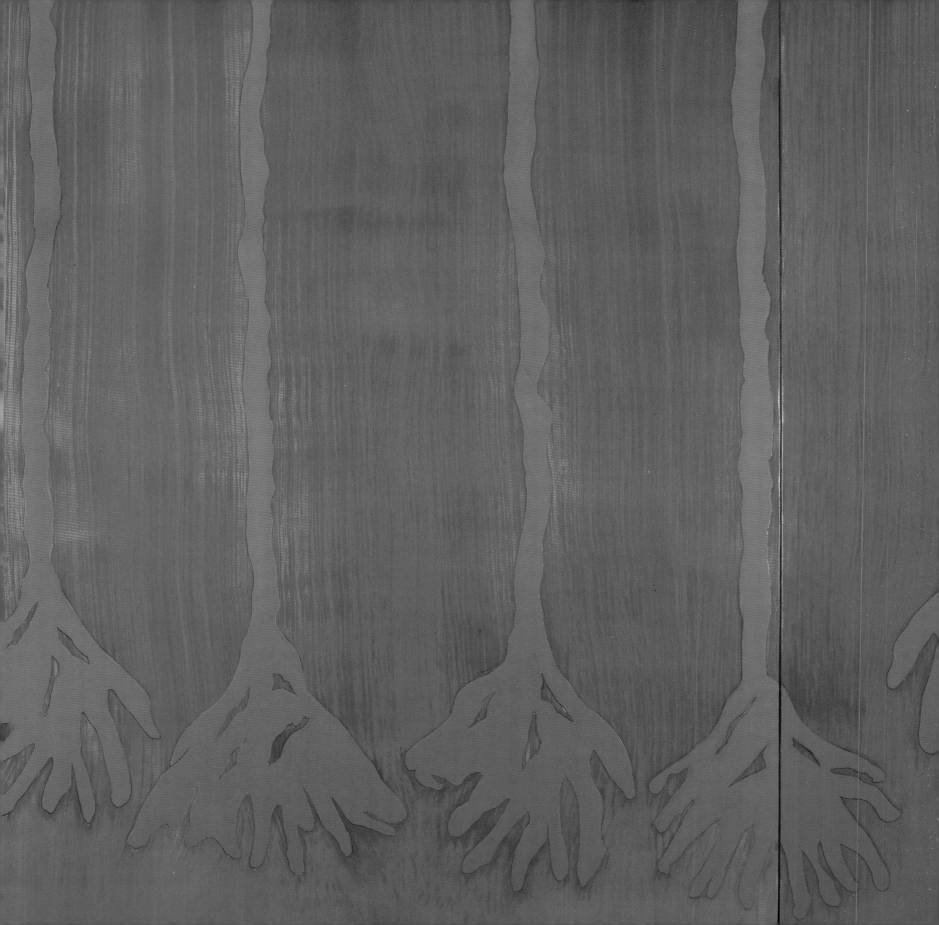

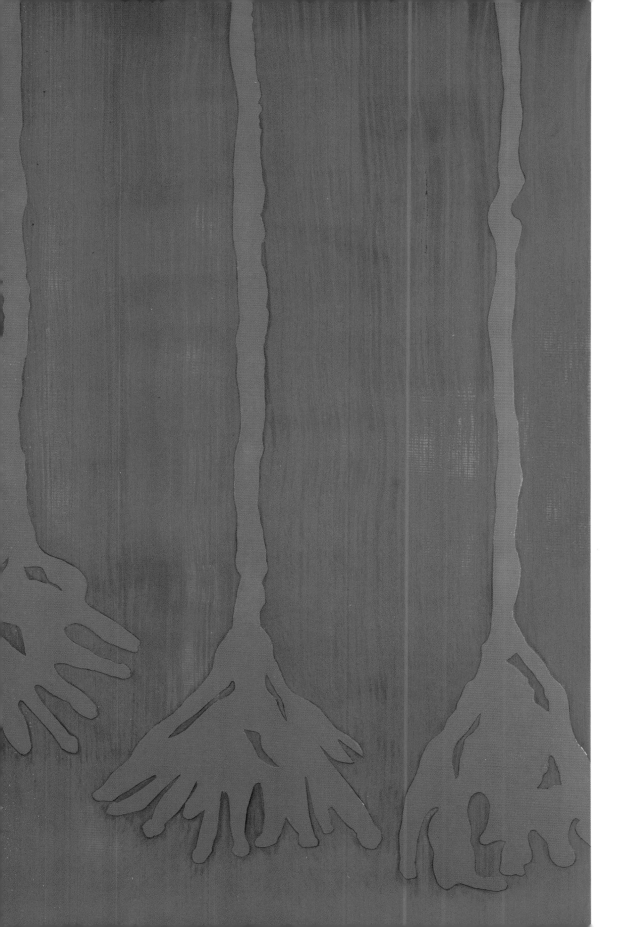

SEEDS OF ABDUCTION 2012
OIL ON CANVAS 103 X 154

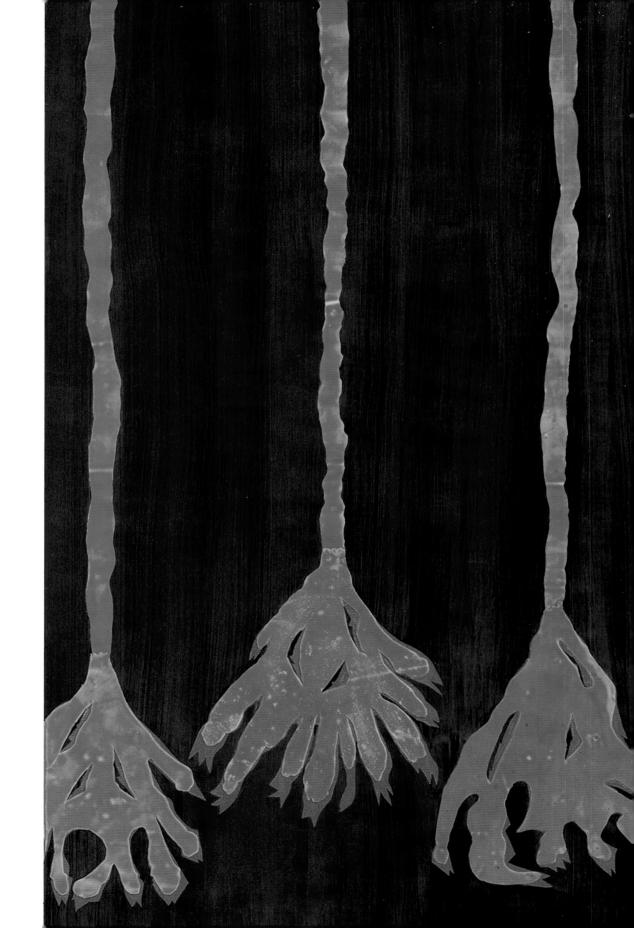

BREATH IN THE AFTERBLOOM 2012
OIL ON CANVAS 103 X 154

OVERLEAF
KISSED BY NIGHTSHADE 2012
OIL ON CANVAS 112 X 231

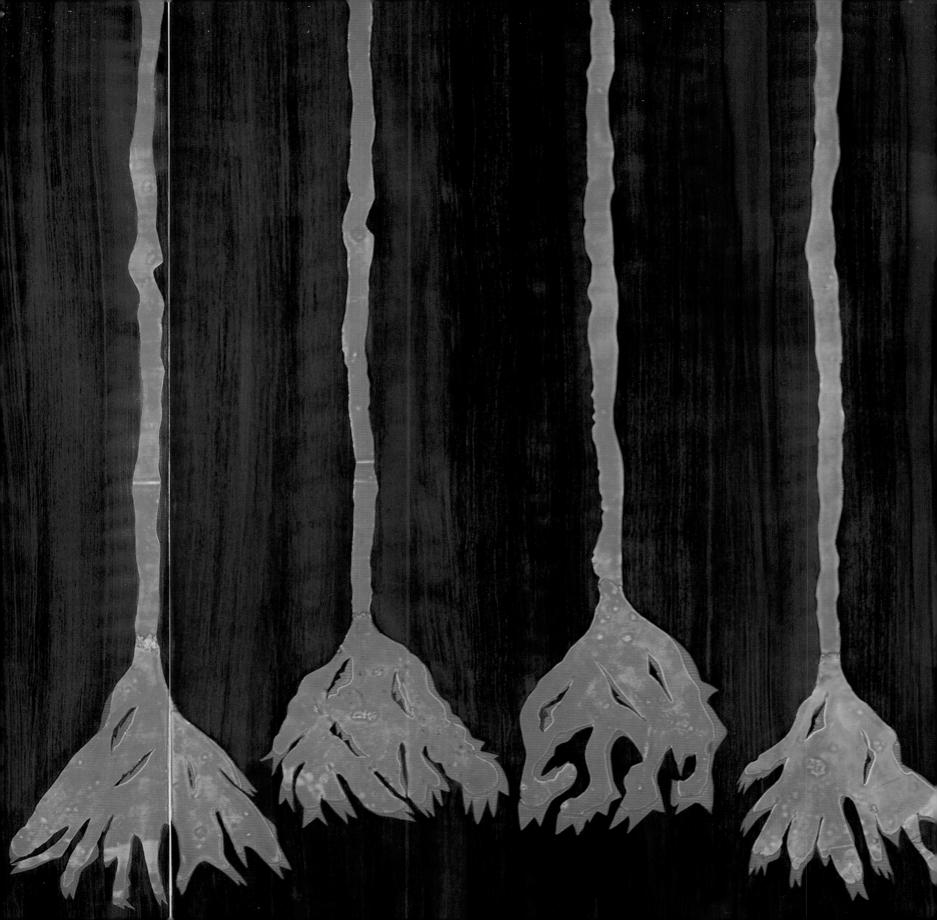

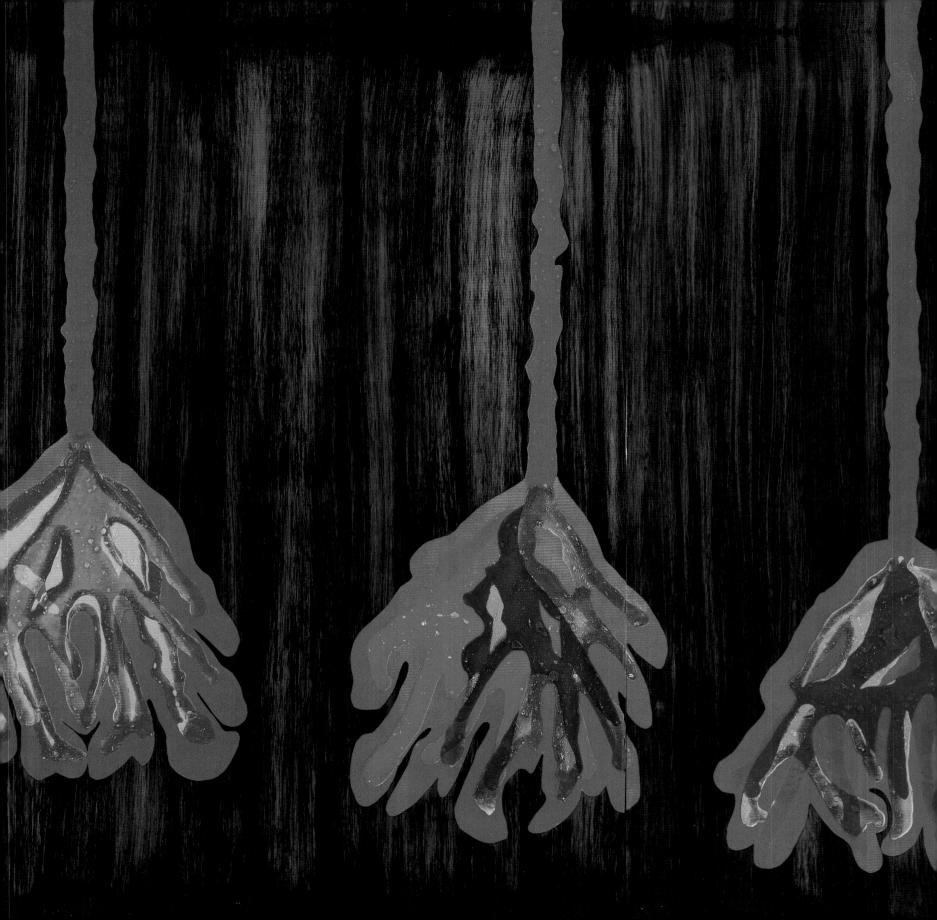

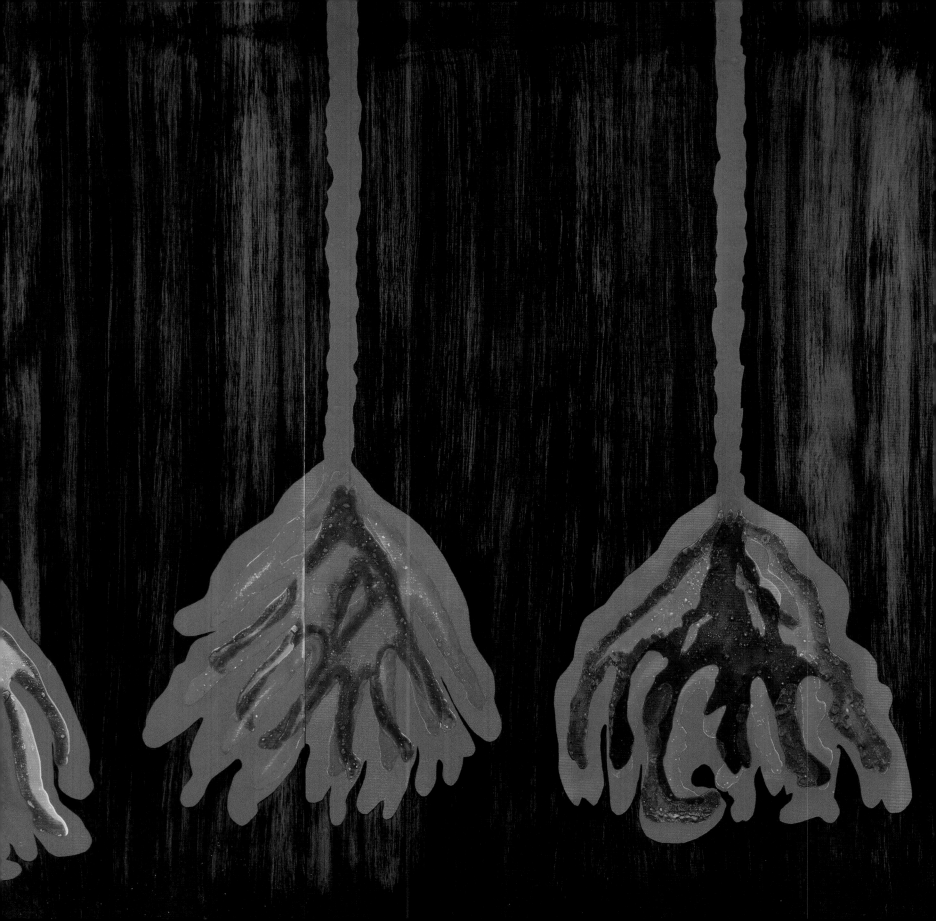

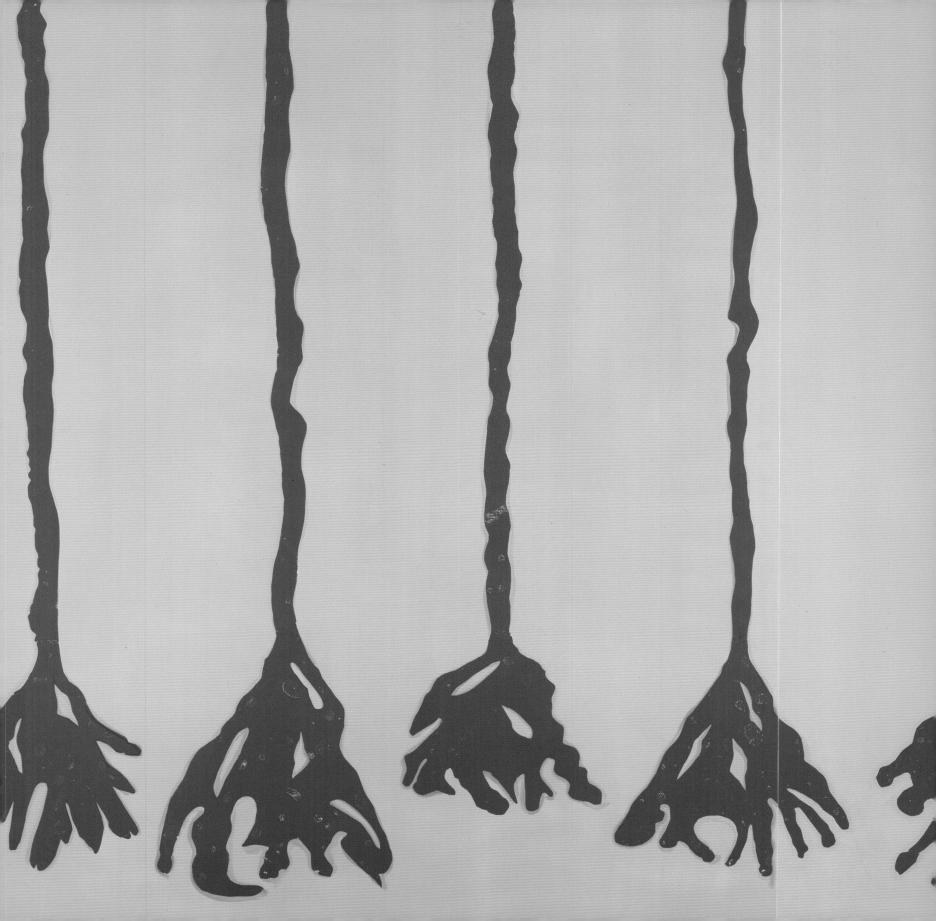

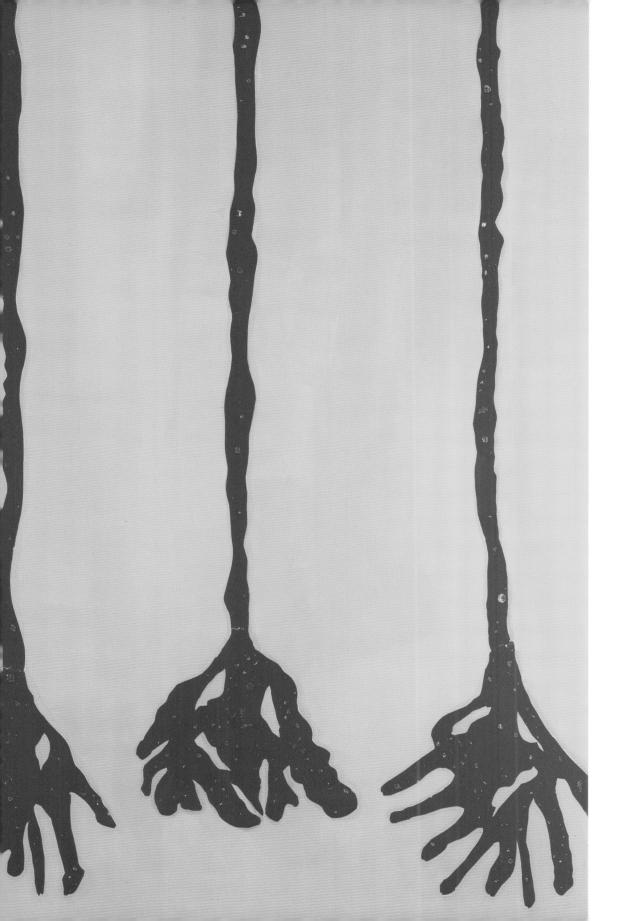

SWEETLY SUBSUMED 2012
OIL ON CANVAS 103 X 154

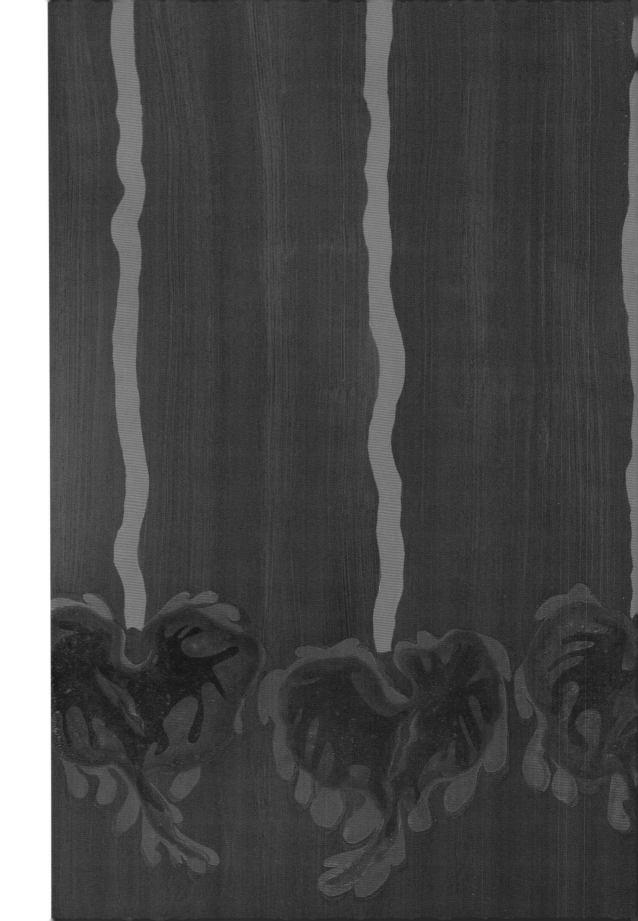

BLEEDING HEARTS
MAKING A COMEBACK 2012
OIL ON CANVAS 103 X 154

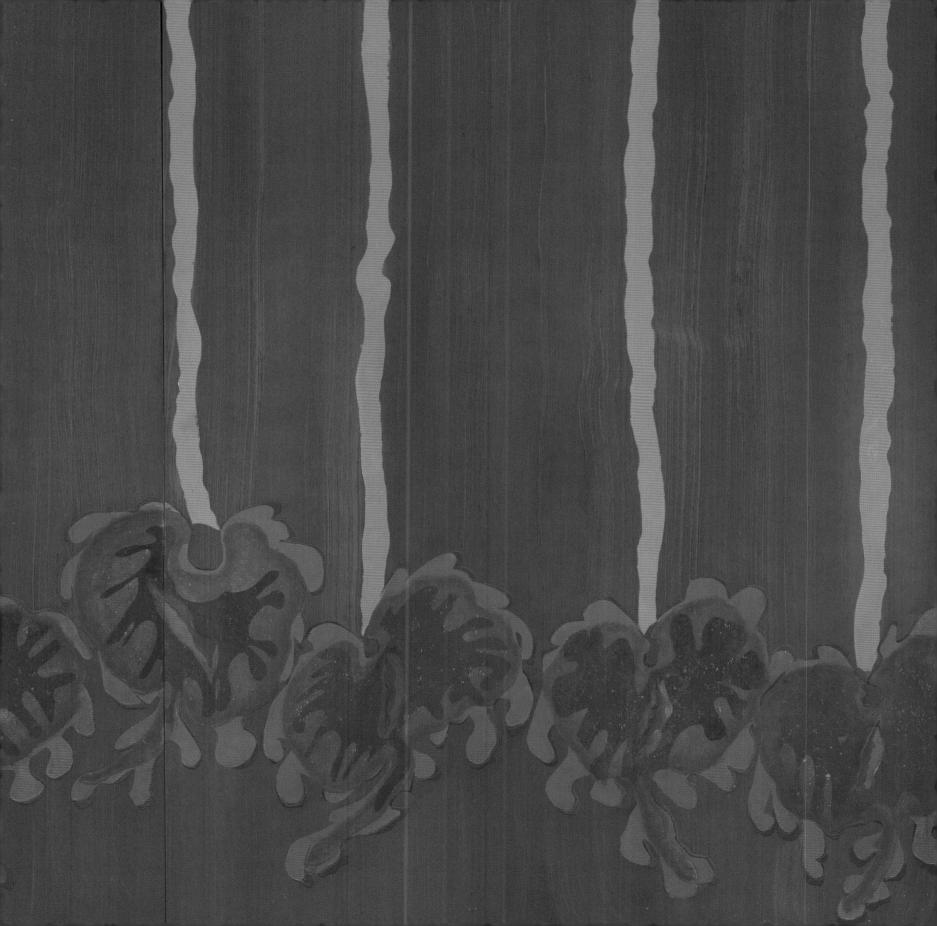

PARTNER OF YOUR MYSTERIES 2012
OIL ON CANVAS 40 X 60

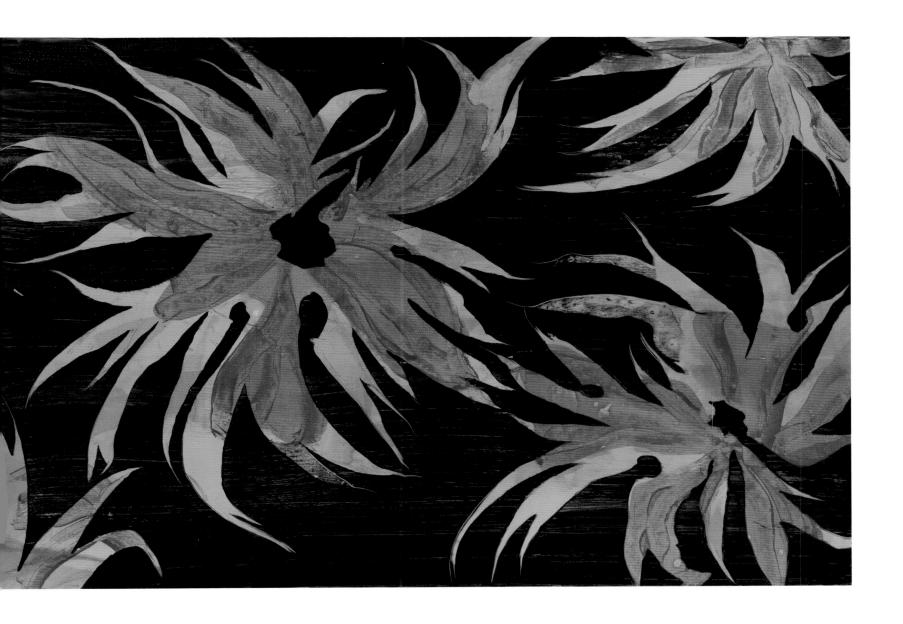

VENOM OF SUGGESTION 2012
OIL ON CANVAS 60 X 60

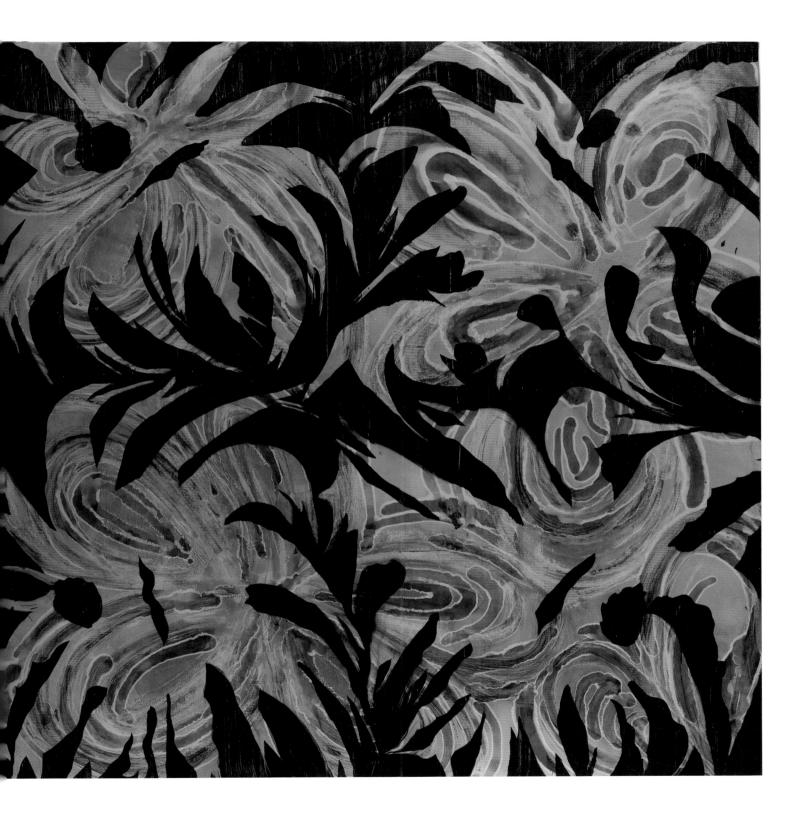

CAME UPON A BURNING BUSH 2012
OIL ON CANVAS 60 X 60

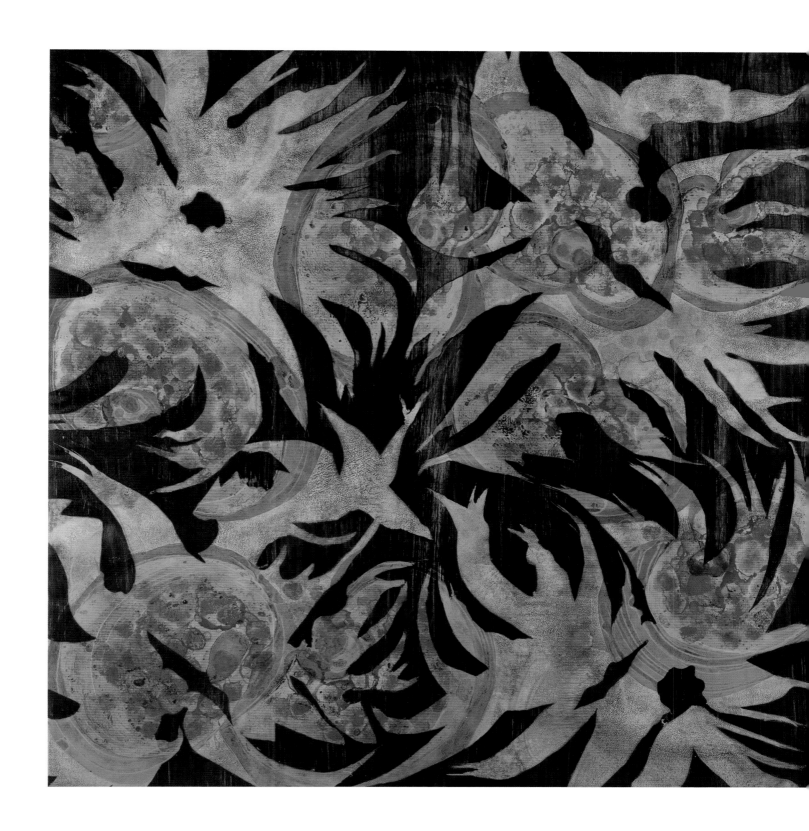

HARD ON FIRE 2012
OIL ON CANVAS 60 X 60

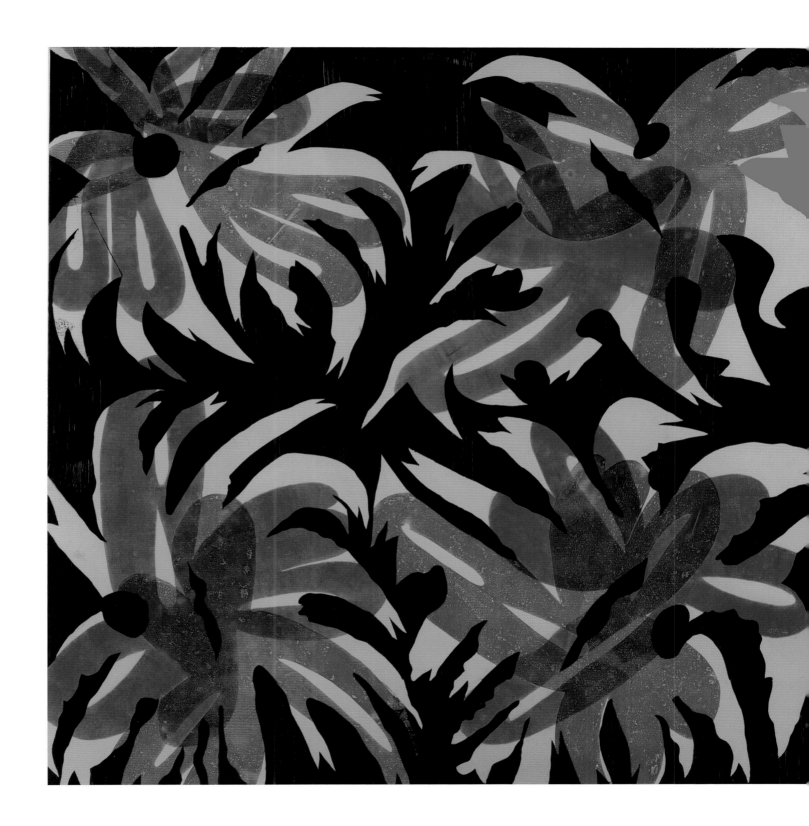

KISS AND SWELL 2012
COLLOGRAPH 44 X 33

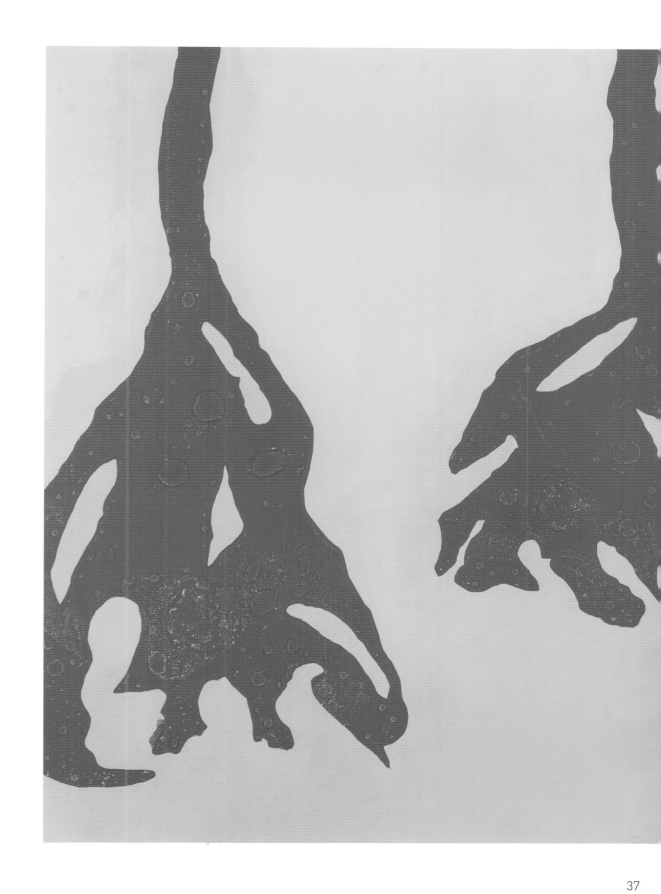

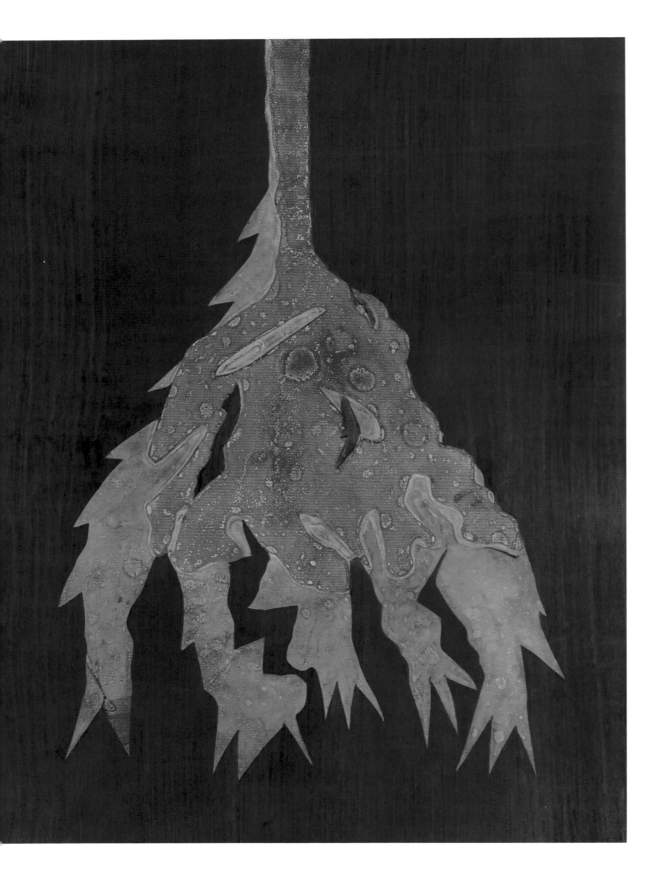

CYAN SIREN 2012
COLLOGRAPH 44 X 33

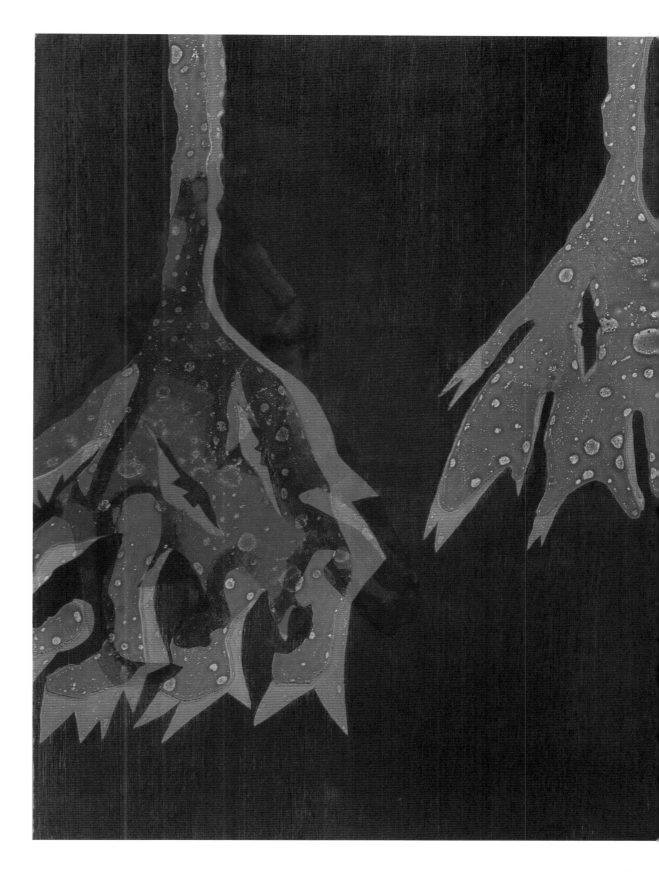

BELLADONNA BLEW 2012
COLLOGRAPH 44 X 33

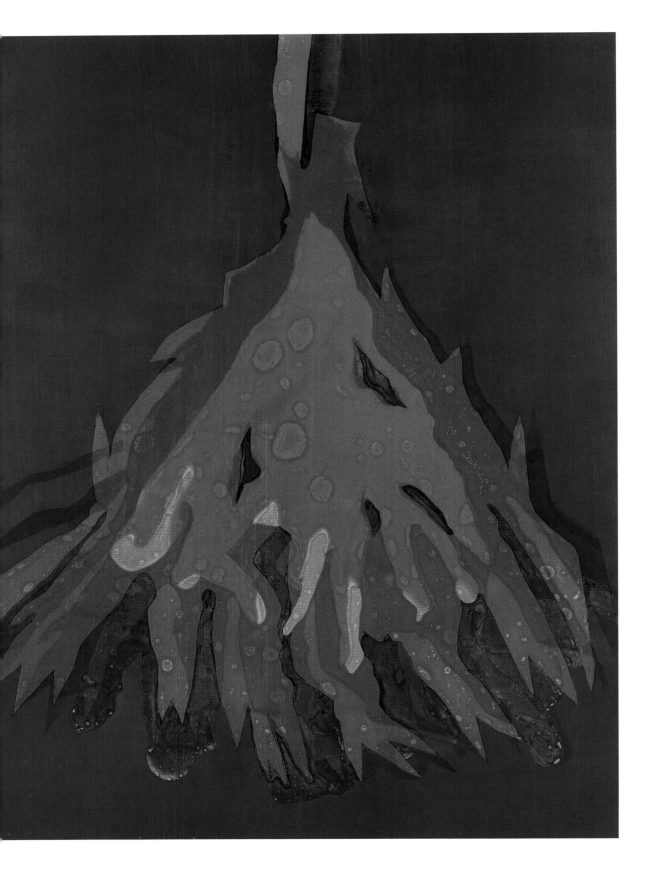

SWOON IN BLOOM 2012
COLLOGRAPH 44 X 33

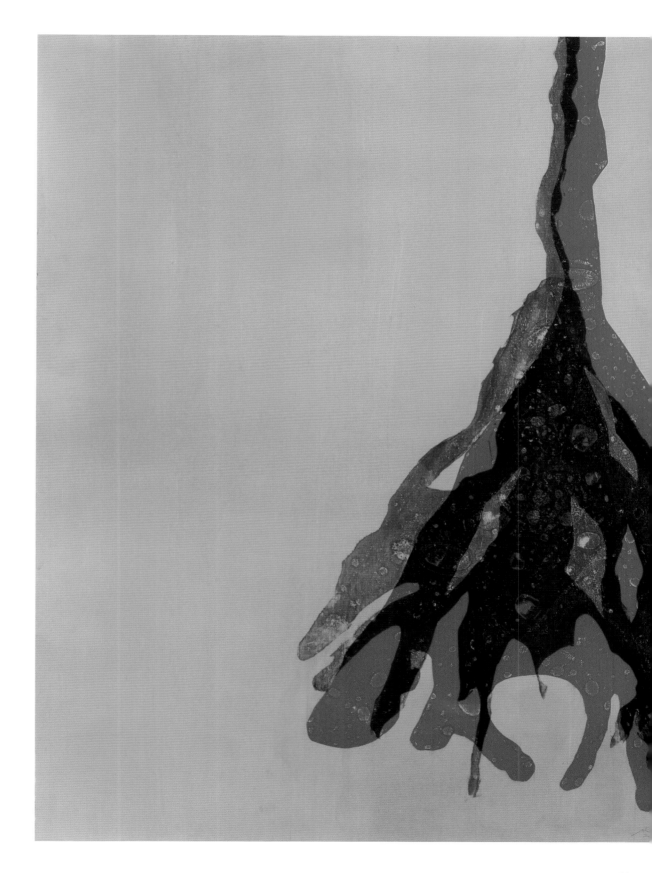

SUN DAY TRIPPER 2012
COLLOGRAPH 44 X 33

EMBRACED ERASED 2012
COLLOGRAPH 33 X 44

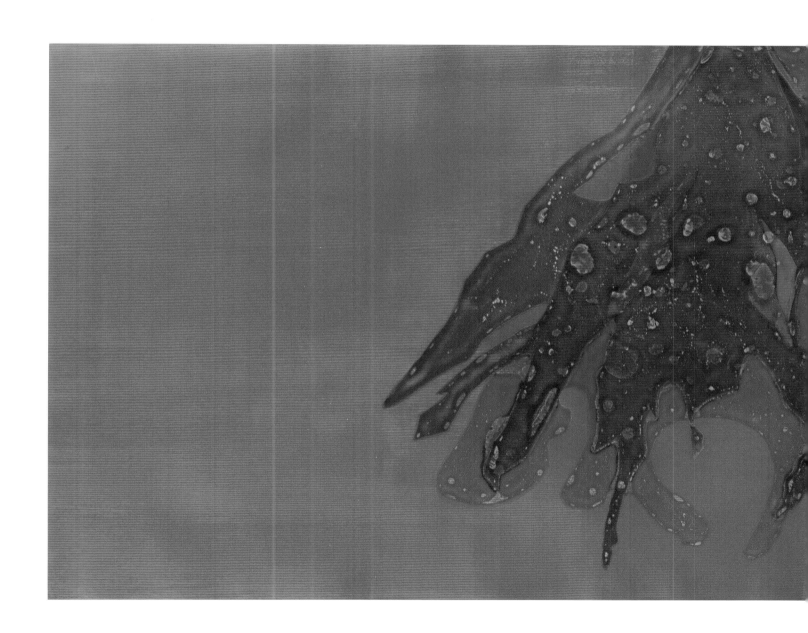

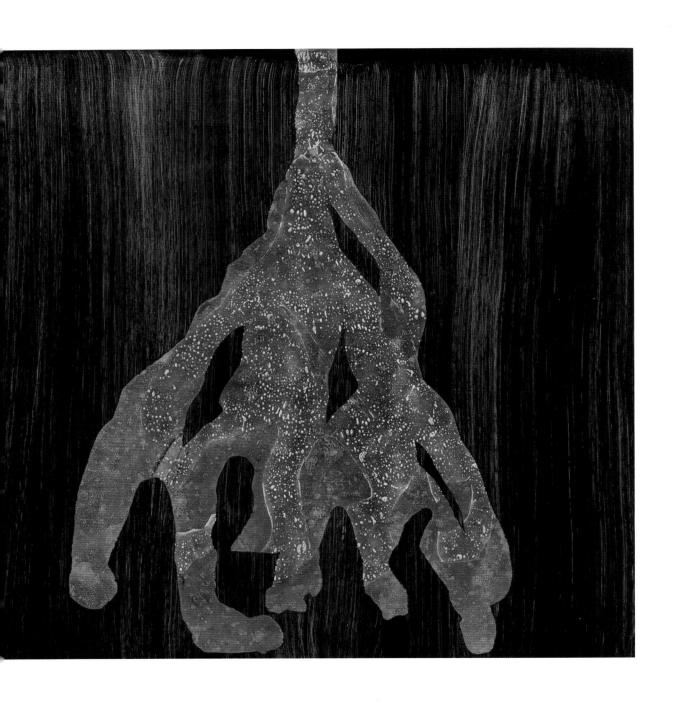

DRINKING DECEIT 2012
OIL ON PANEL 34 X 34

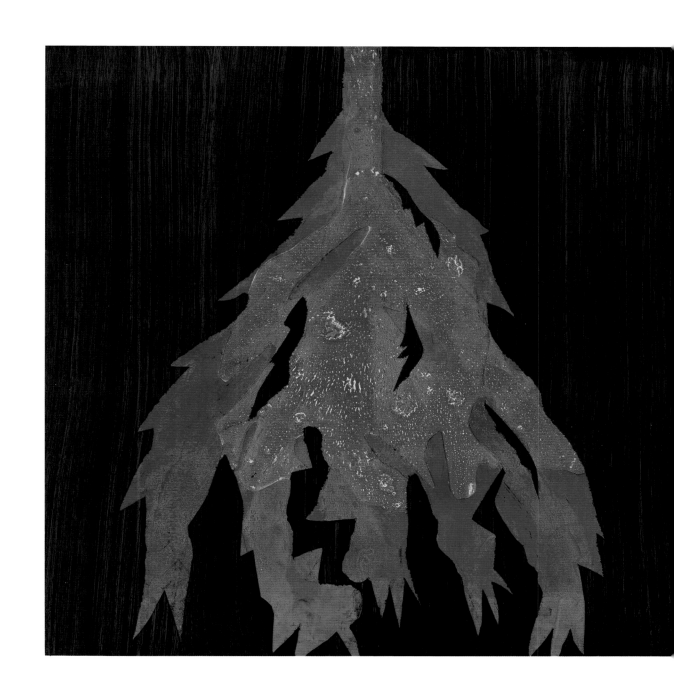

VEIN OF MY EXISTENCE 2012
OIL ON PANEL 34 X 34

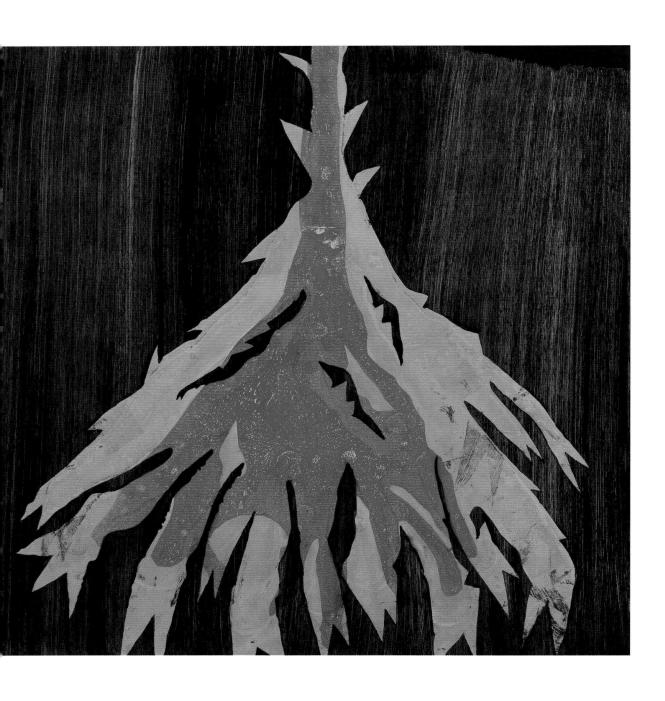

BENEATH DESIRE 2012
OIL ON PANEL 34 X 34

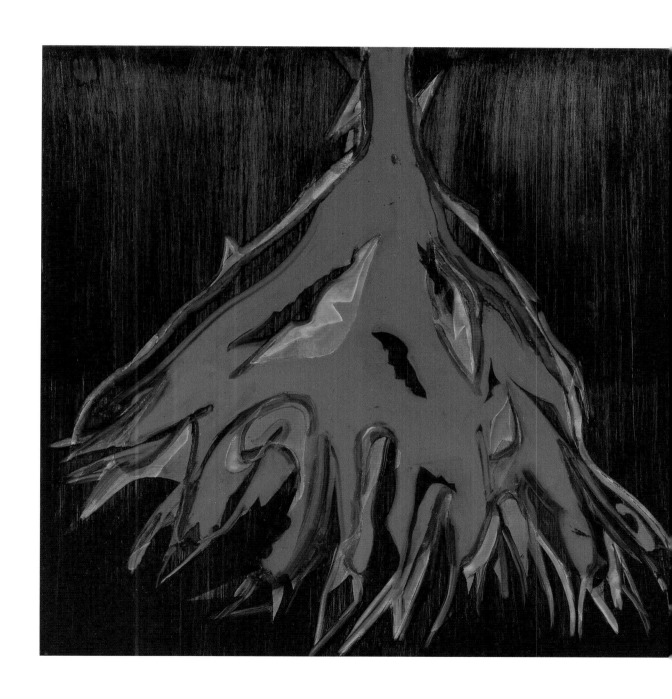

ROSE FROM THE RED 2012
OIL ON PANEL 36 X 36

WHEN THE SUN SHONE THE POISON FLOWER BREATHED COLD 2012
OIL ON PANEL 36 X 36

OVERLEAF
INSTALLATION VIEW, DRISCOLL BABCOCK GALLERIES

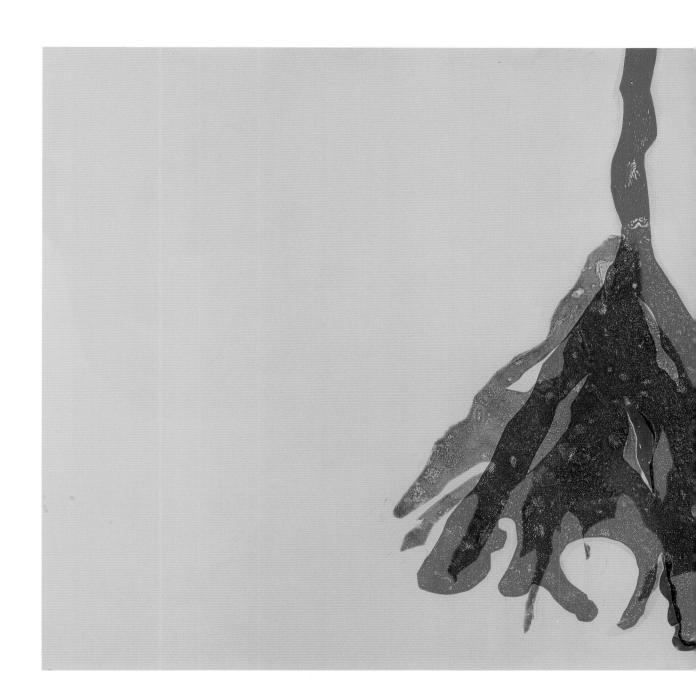

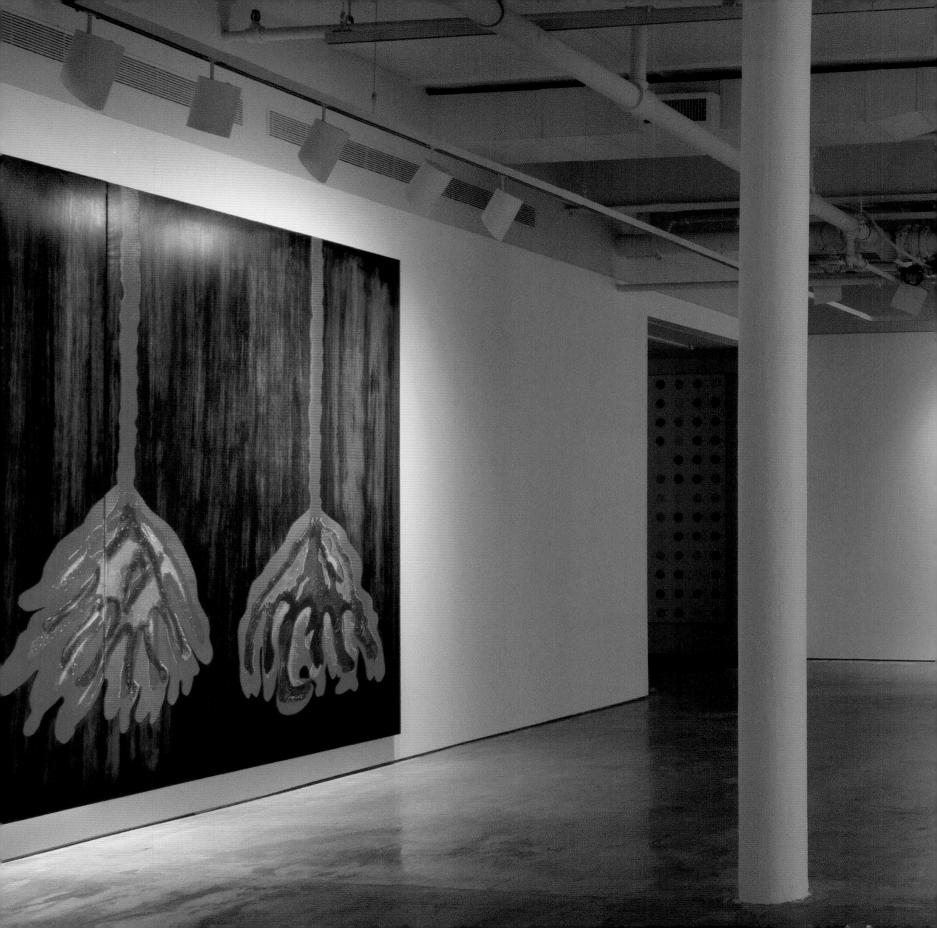

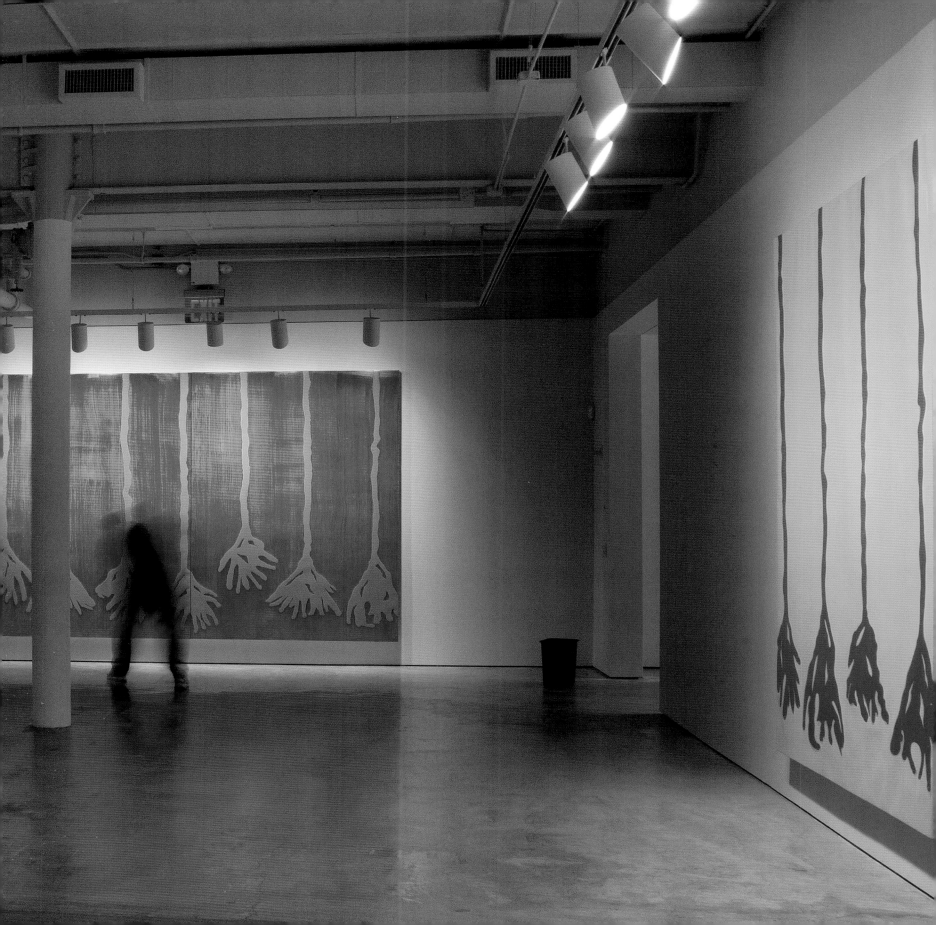

TOKEN THORN PRICK 2012
OIL ON CANVAS 100 x 77

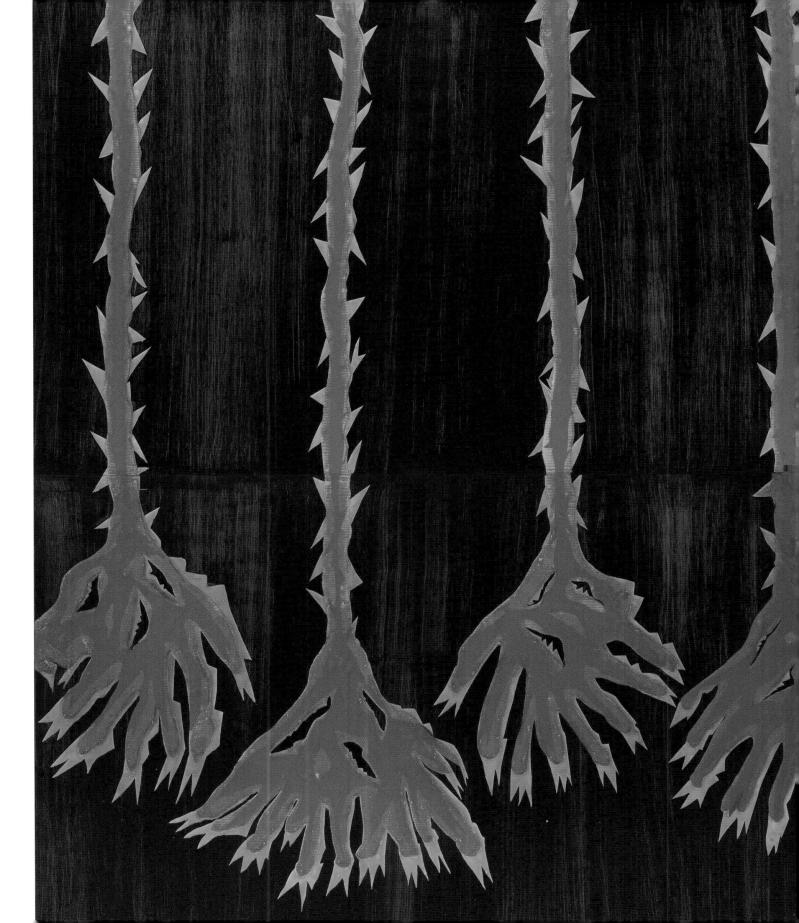

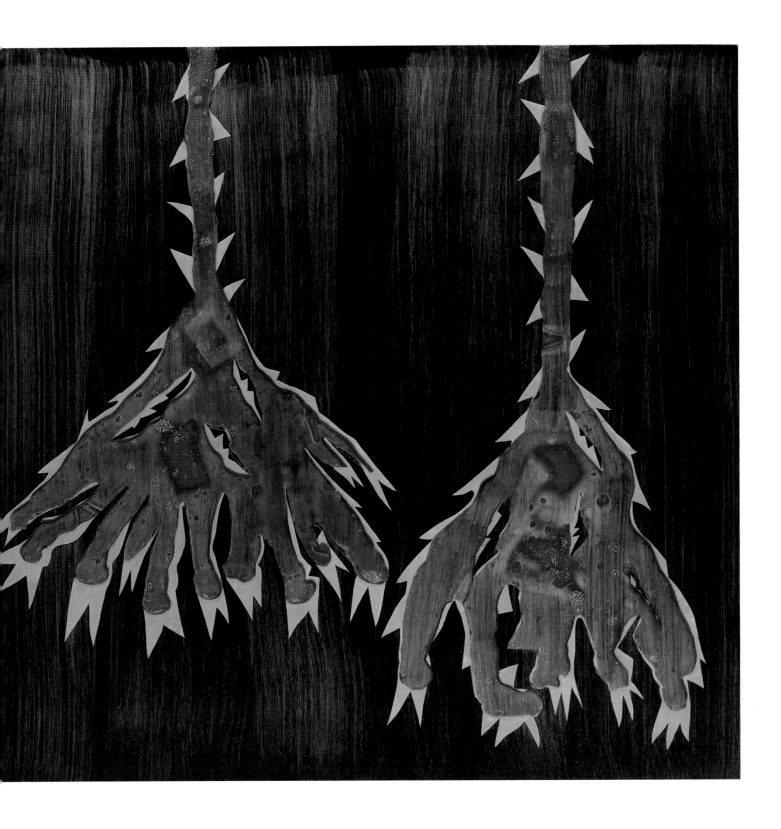

SPREADING YEW 2012
OIL ON CANVAS 60 X 60

OVERLEAF
INSTALLATION VIEW, DRISCOLL BABCOCK GALLERIES

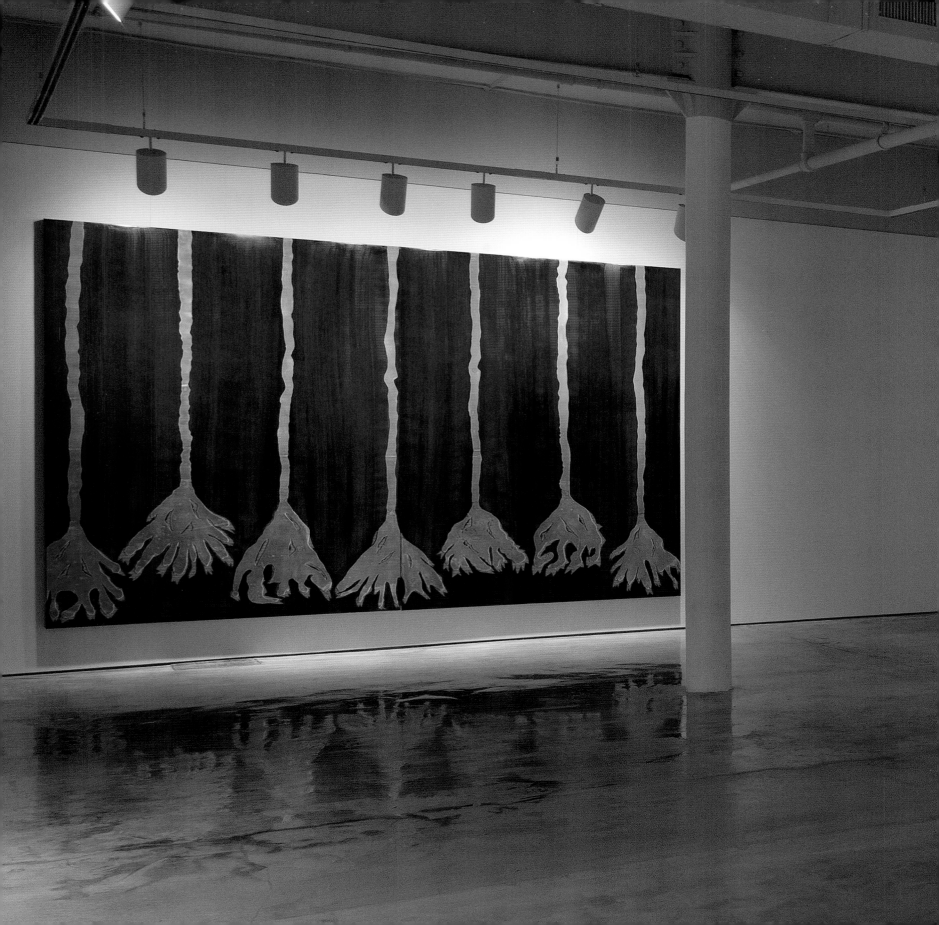

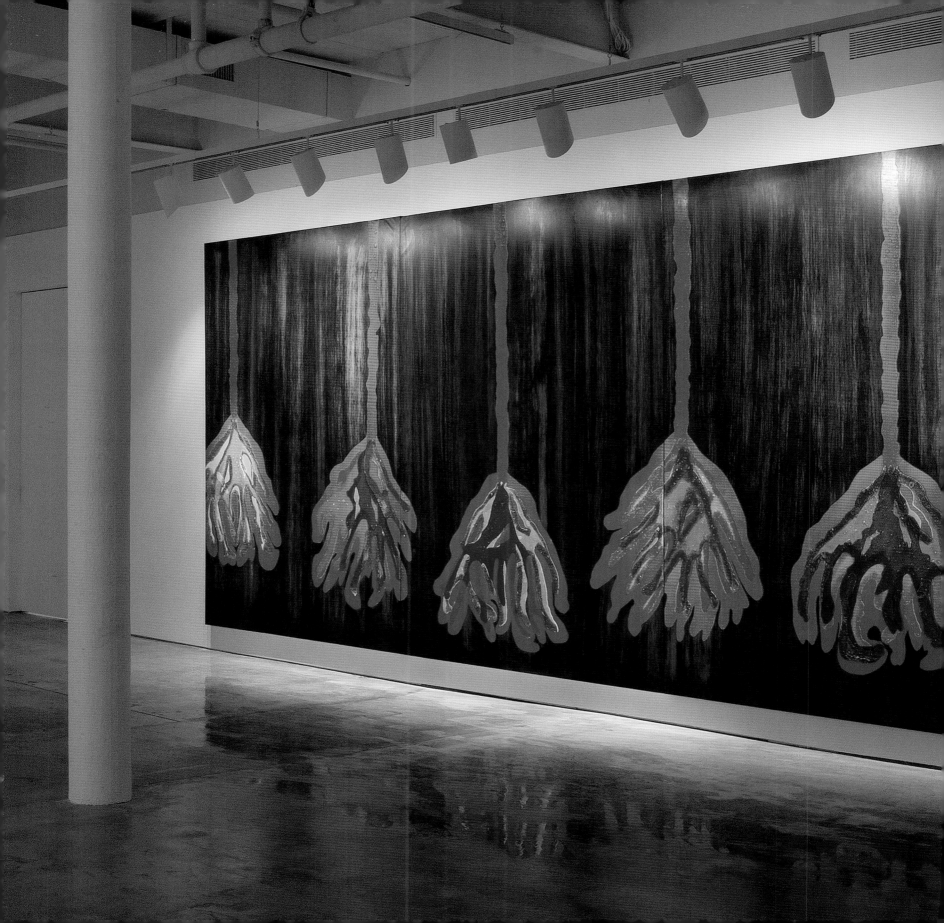

MARYLYN DINTENFASS

SELECTED SOLO EXHIBITIONS

2012
Driscoll Babcock Galleries, New York, *Drop Dead Gorgeous*
Flint Institute of Art, Flint, Michigan, *Auto Biography and Other Anecdotes*

2011
Babcock Galleries, New York, *Souped Up/Tricked Out*

Bob Rauschenberg Gallery, Edison State College, Fort Myers, Florida,
 Marylyn Dintenfass

2010
Babcock Galleries, New York, *Marylyn Dintenfass: Parallel Park*

2009
Babcock Galleries, New York, *Marylyn Dintenfass: Good & Plenty Juicy*

2006
Greenville County Museum of Art, Greenville, South Carolina,
 Marylyn Dintenfass Paintings

Mississippi Museum of Art, Jackson, *Work in Progress: Marylyn Dintenfass*

Franklin Riehlman Fine Art, New York, *Marylyn Dintenfass: Recent Paintings*

Pelter Gallery, Greenville, South Carolina, *Marylyn Dintenfass: Works on Paper*

1994
Hamline University, Saint Paul, Minnesota, *Marylyn Dintenfass: Clay in Print*

1991
Terry Dintenfass Gallery, New York, *Paradigm Series*

1985
The Port Authority of New York and New Jersey, Bus Terminal, 42nd Street,
 New York, A.R.E.A. Project Site Installation, *Imprint Fresco*

1980
Katonah Museum of Art, Katonah, New York, *Tracks & Traces*

1979
Robert L. Kidd Galleries, Birmingham, Michigan, *Porcelain Progressions*

1978
Bell Gallery, Greenwich, Connecticut, *Porcelain Progressions*

1977
Schenectady Museum, Schenectady, New York, *Marylyn Dintenfass*

1976
Queens Museum of Art, Queens, New York, *Installation*

SELECTED COMMISSIONS/PUBLIC INSTALLATIONS

Aetna Life Insurance Company, Hartford, CT

Baltimore Federal Financial Building, Baltimore, MD

Bayerische Landesbank, New York, NY

Boston Consulting Group, New York, NY

Charles E. Smith Company, Los Angeles, CA

Crystal City Complex, Arlington, VA

Flint Institute of Art, Flint, MI

Freddie Mac Headquarters, McLean, VA

IBM, San Jose, CA; Charlotte, NC; Atlanta, GA

Kaiser Permanente, Dallas, TX

Lee County Justice Center, Fort Myers, FL

Main Hurdman, Park Avenue Plaza, New York, NY

National Reinsurance Corporation, Stamford, CT

Pfizer Inc., New York, NY

The Port Authority of New York and New Jersey, Bus Terminal 42nd St.

State of Connecticut Superior Court Complex, Enfield, CT

Thompson, Ventulett, Stainback & Associates, Atlanta, GA

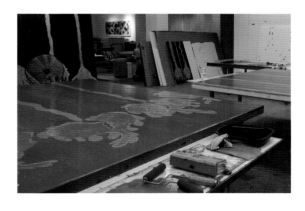

SELECTED PUBLIC COLLECTIONS

Ackland Art Museum, University of North Carolina, Chapel Hill

Art Museum of South Texas, Corpus Christi

Ben-Gurion University of the Negev, Be'er Sheva, Israel

Borough of Manhattan Community College, City University of New York

The Butler Institute of American Art, Youngstown, Ohio

Cheekwood Museum of Art, Nashville, Tennessee

The Cleveland Museum of Art, Ohio

Columbus Museum of Art, Ohio

Danmarks Keramikmuseum, Grimmerhus, Middelfart, Denmark

Detroit Institute of Arts, Michigan

Samuel Dorsky Museum of Art, State University of New York at New Paltz

Everson Museum of Art, Syracuse, New York

Fitchburg Art Museum, Massachusetts

Flint Institute of Arts, Michigan

Greenville County Museum of Art, South Carolina

Lee County Justice Center, Fort Myers, Florida

The Metropolitan Museum of Art, New York

Eli and Edythe Broad Art Museum, Michigan State University, East Lansing

Minneapolis Institute of Arts, Minnesota

Mississippi Museum of Art, Jackson

Municipal City Hall, Be'er Sheva, Israel

Museo Internazionale delle Ceramiche, Faenza, Italy

Museum of Arts and Design, New York

The Museum of Fine Arts, Houston, Texas

New Orleans Museum of Art, Louisiana

Palmer Museum of Art, Pennsylvania State University, University Park

Smithsonian American Art Museum, Washington, DC

State of Connecticut Superior Courthouse, Enfield

Tajimi Middle School, Tajimi City, Gifu, Japan

United States Department of State, Art Bank Program, Washington, DC

Jane Voorhees Zimmerli Art Museum, Rutgers University, New Brunswick,NJ

Worcester Art Museum, Massachusetts

SELECTED LECTURES AND PRESENTATIONS

Cincinnati Art Museum, OH, Studio Visit, 2013

The MacDowell Colony, New York, Visual Presentation, The Time Center, 2012

The MacDowell Colony, New York, Studio Interview/Presentation, 2012

Art on Air Radio, Brooklyn, NY, Broadcast of CUE Foundation Interview with Irving Sandler, 2012

PowerHouse Arena, Brooklyn, NY, Interview/Presentation, 2012

Z-100 Radio, New York, Interview, 2012

University of Colorado Boulder, Lecture, 2012

CUE Art Foundation, New York, Interview with Irving Sandler, 2011

Caroline Collective, Houston, TX, Lecture, 2011

Edison State College, Fort Myers, FL, Gallery Lecture/Presentation, 2011

Material Connexion, New York, Juror–New Materials, 2011

The Art Institute of Chicago, IL, Studio Visit, 2010

Gulf Coast Live, WGCU Public Radio, Interview, 2010

Museum of Arts and Design, New York, Studio Visit, 2010

WINK-TV, Fort Myers, FL, Interview, 2010

Babcock Galleries, New York, Interview with Irving Sandler, 2009

Los Angeles County Museum of Art, CA, Studio Visit, 2009

Syracuse University, New York, Visiting Artist/Lecturer, 2007

Mississippi Museum of Art, Jackson, Presentation/Interview, 2006

Purchase College, School of Art and Design, New York, Panel, 2003

Parsons School of Design, New York, Visual Design Presentation, 1999

NYU Interactive Telecommunication Program, New York, Presentation, 1999

International Society for Radio and Television, New York, Panel, 1998

The Metropolitan Museum of Art, New York, Presentation, 1998

The MIT Enterprise Forum, New York, Presentation, 1996

MacWorld, San Francisco, Boston, and Washington, DC, 1993-1998. (eleven conference presentations).

United States Embassy Cultural Center, Tel Aviv, Israel, Presentation, 1993

National College of Art and Design, Bergen/Oslo, Norway, Visiting Professor, 1991/1992

Academie Minerva, Groningen, The Netherlands, Lecture, 1991

Gaesteatelier Hollufgard, Odense, Denmark, Workshop/Lecture, 1990

MoMA P.S.1, Long Island City, New York, Artist Colonies/MacDowell, Panel, 1990

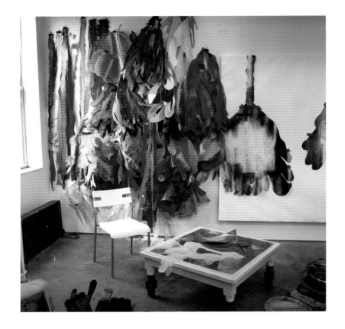

SELECTED BIBLIOGRAPHY

Adkins, Roy. "The Fourth Quadrant." *Jackson* (Mississippi) *Free Press*, 14 Sept. 2006.

"After Sandy Delays and Fundraiser, Marylyn Dintenfass Show Opens at Driscoll Babcock." *ARTINFO*, Web. 20 Nov. 2012.

Castle, Frederick Ted. "The Clay Paintings of Marylyn Dintenfass." *Ceramics: Art and Perception*, no. 8 (1992): 7–9.

——. *Marylyn Dintenfass: Paradigm Series*. Exh. cat., New York: Terry Dintenfass Gallery, 1991.

Dantzic, Cynthia Maris. *100 New York Painters*. Atglen, PA: Schiffer, 2006.

Dintenfass, Marylyn. "Paving Paradise." *NY Arts Magazine*, May 2012: 52.

Driscoll, John. *The American Hand: Sculpture from Three Centuries*. Exh. cat., NY: Babcock Galleries, 2012.

Edelman, Aliza, et al. *Marylyn Dintenfass: Parallel Park*. Lenox, MA: Hard Press Editions, 2011.

Ehrlich, Kate and Austin Henderson. "Building Vocal Space: Expressing Identity in the Radically Collaborative Workplace: Interview with Hani Asfour and Marylyn Dintenfass." *Interactions 8*, Jan/Feb 2001: 23–29.

Grabowski, Beth and Bill Fick. *Printmaking: A Complete Guide to Materials and Processes*. Upper Saddle River, NJ: Prentice Hall, 2009.

"Inside Travel & Tourism." WINK-TV (Fort Myers, FL), 30 July, 2010.

"Irving Sandler and Marylyn Dintenfass, Parallel Park." ArtonAir.org (Brooklyn, NY), 5 Mar. 2012.

Jones, Tracy. "Downtown Fort Myers 'Parallel Park': Artist on Site this Week." *Grandeur Magazine*. Web. 25 May 2010.

Jovanovic, Rozalia. "Marylyn Dintenfass' Deadly Blooms." *The Huffington Post*. Web. 18 Jan. 2013.

Kiniry, Mike. "Interview with Marylyn Dintenfass and Barbara Hill." Gulf Coast Live, WGCU Public Radio (Fort Myers, FL), 8 July 2010.

Marylyn Dintenfass Paintings. Exh. cat., Greenville, SC: Greenville County Museum of Art, 2006.

Mauzy, Jeff and Richard A. Harriman. *Creativity Inc.: Building an Inventive Organization*. Cambridge, MA: Harvard Business School Press, 2003.

Meier, Allison. "22 Questions with Abstract Painter of the Beautiful and the Deadly Marylyn Dintenfass." *ARTINFO*. Web. 30 Dec. 2012.

Mendelsohn, Meredith. "Marylyn Dintenfass: Babcock Galleries." Review of *Marylyn Dintenfass: Good & Plenty Juicy. ARTnews*. Summer, 2009: 124.

Miller, Donald. "Wheel Estate." *Marylyn Dintenfass: Parallel Park. ARTnews*. January 2012: 34.

"The 100 Best Fall Shows." *Marylyn Dintenfass: Drop Dead Gorgeous. Modern Painters Magazine*. Sept. 2012: 81.

"The 100 Best Fall Shows." *Marylyn Dintenfass: Souped Up/Tricked Out. Modern Painters Magazine*. Sept. 2011: 70.

Piersol, Daniel. "From Another Dimension: Works on Paper by Sculptors." *Arts Quarterly* (New Orleans Museum of Art), vol. 26, no. 2 (2004).

Riddle, Mason. *Marylyn Dintenfass: Clay in Print*. Exh. cat., Saint Paul, MN: Hamline University, 1994.

Robinson, Joyce Henri. *Marylyn Dintenfass: The Art of the Sensual Grid*. Exh. cat. for *Work in Progress: Marylyn Dintenfass*. Jackson: Mississippi Museum of Art, 2006.

Sandler, Irving. *Interview with Marylyn Dintenfass*. Full Res Productions, YouTube, 2009. Web. 3 June 2009.

Schwab, Tess Sol. *Slipping Glimpses: American Abstraction, 1920-2010*. Exh. cat., NY: Babcock Galleries, 2012.

Stetson, Nancy. "Color Queen." *Fort Myers Florida Weekly*, Jan.19-25, 2011: C1, C4.

——. "Parallel Park: Modern Art Adorns Parking Garage Downtown." *Fort Myers Florida Weekly*, 6 June, 2010.

Walker, Barry. "New Prints 2004/Spring." *International Print Center New York Newsletter*, May 2004. Published with the exhibition *New Prints 2004*, International Print Center, New York.

Wei, Lilly. *Marylyn Dintenfass Paintings*. Manchester, NH and New York: Hudson Hills Press, 2007.

Williams, Roger. "2009: The Year in Ideas." Marylyn Dintenfass: *Parallel Park. Fort Myers Florida Weekly*, Aug. 2009.

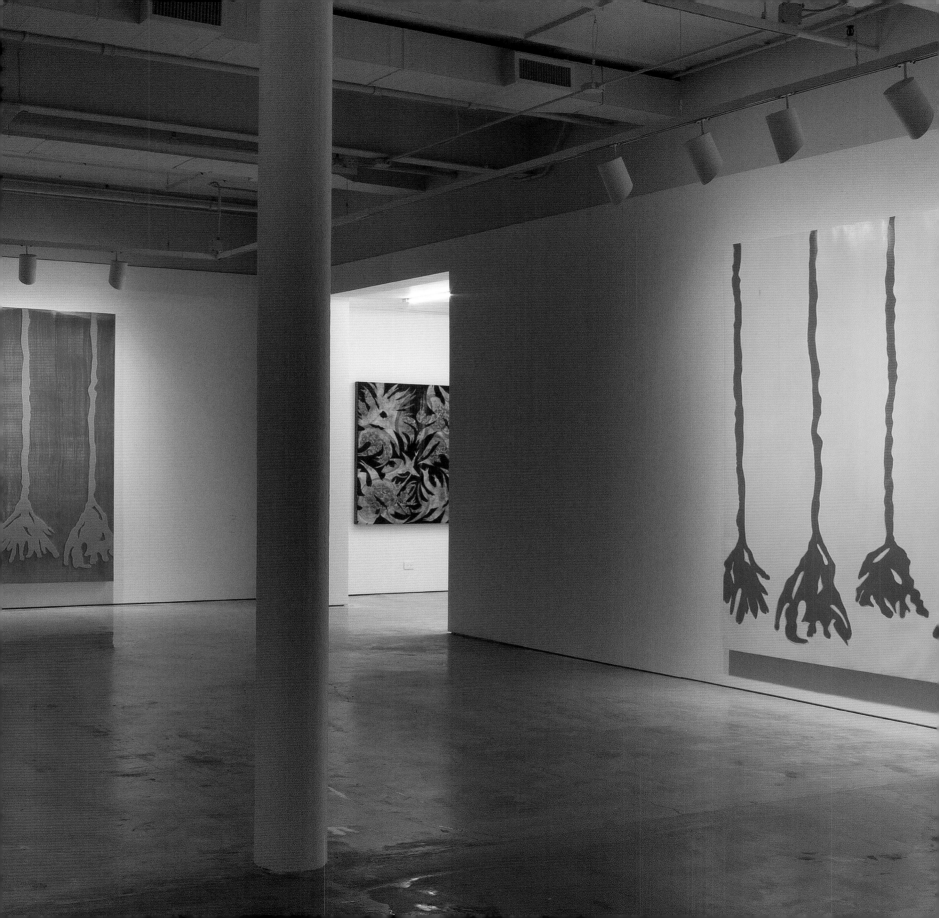

Book Design:
Driscoll Babcock Galleries
Paul Kerin

Photography: All Photography Tim Pyle, Light Blue Studio, except as noted:

Noel Allum, p. 4 / Theo Coté, p. 15, 60, 61 / Francisco Donoso, p.64
Howard Goodman, p.3 / Alexis Medina, p. 64 / Oliver Peters, p.7, 62
JoAnn Sieburg-Baker, p. 12 / Jules Slutsky, p. 16, 17

Printed and bound in China by Regent Publishing Services, Hong Kong

Library of Congress Cataloguing-in-Publication Data

Indrisek, Scott
Marylyn Dintenfass; Drop Dead Gorgeous
with Introduction by John Driscoll, Ph.D.
1st ed.
ISBN-13: 978-0-615-78186-0
ISBN-10: 0-615-78186-0
Includes biographical references

MARYLYN DINTENFASS is represented by Driscoll Babcock Galleries
Driscoll Babcock Galleries
525 West 25th Street
New York, NY 10001
+1 212.767.1852
info@driscollbabcock.com
www.driscollbabcock.com

This catalogue accompanies the exhibition

MARYLYN DINTENFASS: DROP DEAD GORGEOUS
November 17, 2012 - January 26, 2013